IMAGES
of America

URBANA

D1501159

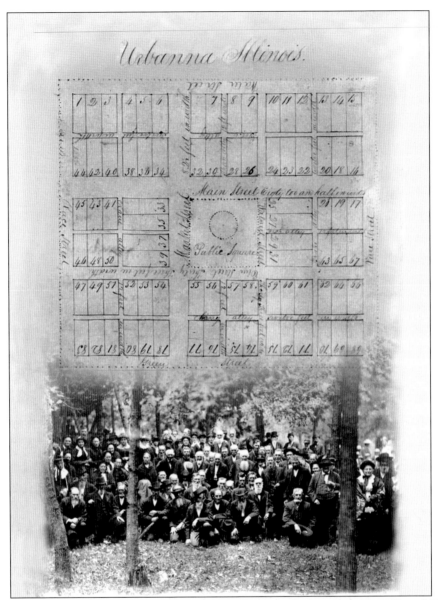

Members of the Old Settlers' Society are seen here photographed on June 28, 1883, in Urbana's Crystal Lake Park at the semicentennial celebration of the establishment of Champaign County. The society was formed on May 16, 1870, "to rescue from oblivion the incidents and recollections of the early days." Above them is the plat map of the original town of Urbana, made on September 3–4, 1833. (Courtesy of the Champaign County Historical Archives and Drím Design.)

On the cover: This is the fifth Champaign County Courthouse built in 1900 and 1901 after the plans of Joseph W. Royer, Urbana's premier architect of the late 19th to mid-20th century. The construction and individual histories of the five courthouses built in the city's center over the years have been highly symbolic of the events that have shaped the city's history. (Courtesy of the Champaign County Historical Archives.)

IMAGES
of America

URBANA

Ilona Matkovszki and Dennis Roberts

ARCADIA
PUBLISHING

Copyright © 2009 by Ilona Matkovszki and Dennis Roberts
ISBN 978-0-7385-6045-8

Published by Arcadia Publishing
Charleston SC, Chicago IL, Portsmouth NH, San Francisco CA

Printed in the United States of America

Library of Congress Control Number: 2009920830

For all general information contact Arcadia Publishing at:
Telephone 843-853-2070
Fax 843-853-0044
E-mail sales@arcadiapublishing.com
For customer service and orders:
Toll-Free 1-888-313-2665

Visit us on the Internet at www.arcadiapublishing.com

*May the history captured in these pages remind us
of the great efforts expended by those of the past to establish
the community we enjoy today and inspire us to nurture
the creative vision necessary to assure its prosperous future.*

CONTENTS

ACKNOWLEDGMENTS

This volume was inspired by the fascinating stories of the people who created the city we live in today. These stories were gleaned from a myriad of sources lovingly cared for in the archives of our community. First and foremost of these is the Champaign County Historical Archives located at the Urbana Free Library. One could not find a more accommodating, knowledgeable, helpful, and kind staff anywhere. Carolyn Adams and Rosemary Rieske gave me, Ilona, the keys to uncovering the past from scraps of scattered information. They have not only taught me, but they have also got me hooked. Norma Bean has been a beam of light with her warm smile and her resolve to find even the most obscure pieces of information. There is not a shred of paper in the archives that has not gone through the hands of Howard Grueneberg. When all else fails, ask Howard. Karla Gerdes, Marnie Hess, and Eric Fair have always given their best and kindest to find documents and photographs. And finally, director of the archives Anke Voss has given us full access to all the wonderful resources of the archives, for which we extend our most sincere thanks. Built over the past 50 years by the untiring work of many staff members and volunteers, Voss's professional knowledge and commitment is now taking this outstanding institute into the 21st century. A great thank you goes to all.

We would also like to extend our true appreciation to friend and outstanding scholar Brian Adams, whose untiring research has most significantly contributed to the understanding of Urbana's history, for sharing his extensive knowledge with us. Our thanks go also to Jeff Ruetsche, our editor at Arcadia Publishing, for his guidance and patience.

All photographs in this volume, unless otherwise noted, are reproduced by permission of the Champaign County Historical Archives. Additional image sources include the University of Illinois Archives (UIA), where we would like to thank Christopher Prom and William Maher; the Sousa Archives and Center for American Music at the University of Illinois (SA), where thanks go to Scott Schwartz; and the News-Gazette Publishing Company (NG), where we thank publisher John Foreman. Thanks go also to Carl Webber (CW) for providing the Webber family photograph. Some of the photographs were taken by Dennis Roberts (DR) and Ilona Matkovszki (IM), and some illustrations are courtesy of Drím Design.

INTRODUCTION

If you have heard of Urbana, you have certainly heard of the University of Illinois. But have you heard what oysters and cigars have to do with planting this university in the middle of the prairie while the country was singing the post-Civil War blues? Have you heard what Griggs Street, Urbana's shortest and best-hidden street, has to do with those oysters? And while on the topic of edibles, have you heard that the world's best recipe for cooking state representatives came from Urbana's own Isaac Busey, whose simple recipe called for a jug of whiskey with a pinch of dirt? Have you heard that a half-century before he delivered the alma mater to the university, Lorado Taft was picking strawberries just a block south of it in the garden of his father, Don Carlos Taft, better known by his students as the "Great Uncombed?" Did you know that the beautiful maidens posted on the staircase of the university's main library are sisters not only to the crouching giants behind Foellinger Hall, but also to the lawyer who stands in guard of Carle Park along Urbana's Race Street? Have you heard of the opera singer who manufactured, of all things, cigars, and called these smelly sticks "Bouquet?" Such a man once lived in Urbana and was the city's preferred opera singer, while men of central Illinois preferred the scent of his Bouquet. And what about the Boneyard? What do bones have to do with a creek? It is really called Silver Creek, is it not? And have you heard that alligators once swam in the Boneyard, but their preferred habitat was the city's brickyard? Talking about bricks, have you heard of the "Brick King" who once lived in Urbana? And have you ever wondered just who built that funky brick castle on the corner of Elm and McCullough Streets? Although the owner was a king's wife, she did not mind her father foot racing with the Great Emancipator on Urbana's Main Street.

If you do not know the answers to these questions but are curious, this book is for you. As this book is short, however, the answers are not spelled out in full detail. We give you clues, but you will have to connect the dots yourself. After all, a little mystery is always more exciting than a three-hour history lesson on a sunny Friday afternoon. And if one day you feel overwhelmed by the question of why Urbana alligators prefer brickyards to warm ponds, you may get inspired to search for some clues yourself.

CHAMPAIGN COUNTY
ILLINOIS

This early land survey map of the area which became Champaign County in 1833 was made by the United States Government around 1820 and shows the prairies, the groves along the streams, and the section lines. The area's three largest groves were the Salt Fork Grove in the east, Big Grove in the center, and the Sangamon Grove in the northwest. Urbana was established in the county's center, in the Big Grove.

One

IN THE BEGINNING
1820–1850

According to tradition, the Euro-American settling of what is now Champaign County began in 1822. At the time, the area was a wilderness, covered with tall grass prairie and scattered groves. The first settlers, subsistence farmers mostly from Kentucky, were seeking forested areas for the easily worked soils and avoided prairies that were hard to cultivate with the available primitive plows. The forests also provided protection from the elements and timber for fuel and cabin building. In what is now Champaign County, timbered areas were limited. In the first decade, settlement occurred mostly along the edges of Big Grove in the center of the county.

Prior to its establishment as a county, the area of the present Champaign County was so-called unorganized territory that was administratively part of Vermilion County. In 1832, the residents of Big Grove petitioned the Illinois General Assembly for the establishment of a separate county. Negotiations on their behalf by John W. Vance, Vermilion County state senator who was voted into office because of the Big Grove residents, resulted in the successful passage of the bill on February 20, 1833, creating Champaign County and its seat, Urbana, named after Vance's former home in Ohio at his request.

Legislative order had created the county seat, but it was left up to a committee to locate the actual site on June 21, 1833. Expectations were for the more populous northeast Big Grove. The story of how a pioneer settler on the wrong side of the Big Grove ended up persuading the committee to plant the county seat by his cabin in southwest Big Grove is one of the great stories of Urbana's history. It is believed that a jovial night with a bit of whiskey supplied to the committee in Isaac Busey's cabin had as much to do with the decision as the sage resolve of this crafty Kentuckian to donate 30 acres of his own meadowland for the county seat. Even after the city was laid out on the map, the pioneer farmers continued living in their scattered forest cabins, and it was left to the railroad to create a city on the ground.

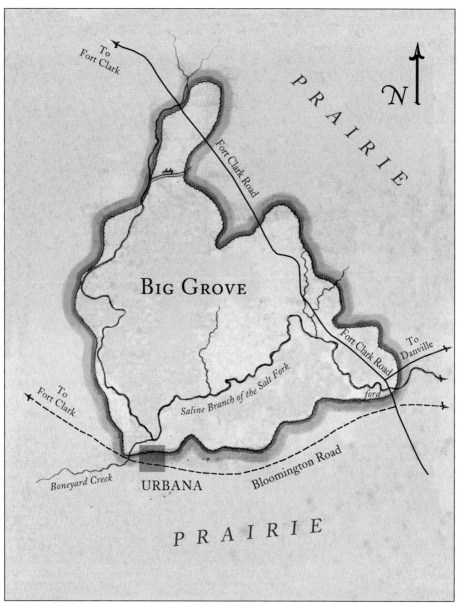

The Big Grove was a forest of majestic, old oak and hickory trees about 12 miles long and on average three miles wide, stretching along the Saline Branch of the Salt Fork River. Big Grove was traversed by Fork Clark Road, a major east–west migration route across the county that connected Indiana to Fort Clark (later Peoria) on the Illinois River. The road ran along the eastern boundary of the Big Grove, following an old Native American trail. Most of the early pioneers settled along this road in the northeast of Big Grove, where an early post office was also established. Expectations were for the county seat to be located here. Due to the intervention of three landowners lead by Isaac Busey, Urbana was established near their cabins in the southwest of Big Grove by the Boneyard Creek, a small tributary of the Saline Branch. Following this, a new road was created along the southern boundary of Big Grove, which became known as Bloomington Road after the town it ran toward west of Urbana. Urbana's Main Street comprised part of the Bloomington Road. (Drím Design.)

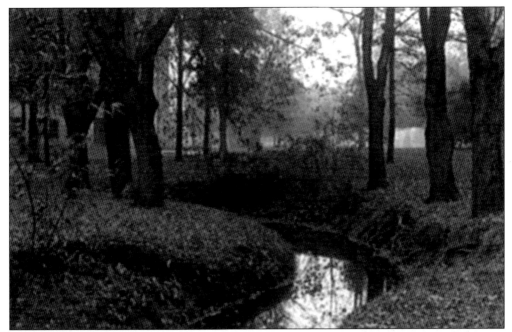

This is the Boneyard Creek as it appeared in the early 20th century. According to tradition, the creek was named after the bones of game animals, which were strewn along its banks when the Euro-American settlers first arrived to the area. These animals were hunted by the Potawatomi Indians, the region's Native American inhabitants at the time.

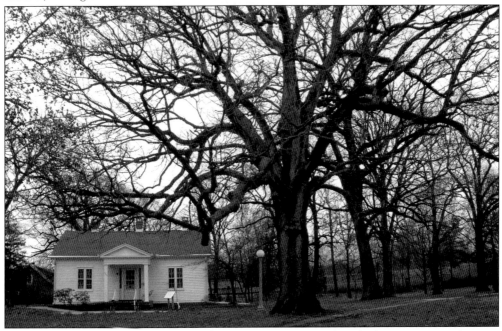

Over 200 years old, this giant oak tree, located in Urbana's Leal Park along University Avenue, is a rare remnant of the Big Grove. The early pioneers settled in forests of such magnificent trees. Leal Park is a former Native American and pioneer burial ground. The small cottage under the tree is an early residence from the 1850s, moved to this location in the 1970s. (DR.)

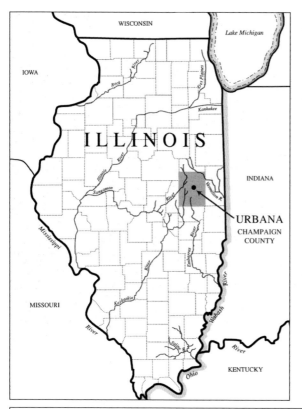

Champaign County was established by the Illinois legislature on February 20, 1833, from so-called unorganized territory, which, for administrative purposes, belonged to Vermilion County and from a 10-mile strip that was in the western part of Vermilion County. The map shown at left shows the location of Champaign County in Illinois. The close-up map on the left side in the image below shows the territorial organization in 1831 before Champaign County was established. The territory of Vermilion County as established in 1826 is shaded. The close-up map on the right side shows the territorial organization in 1835 after Champaign County was formed and the size of Vermilion County was reduced in the west. The boundaries of Champaign County have remained the same since its establishment. (Drím Design.)

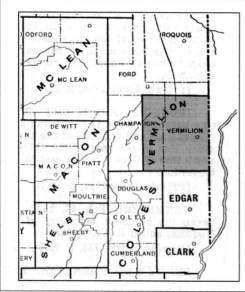
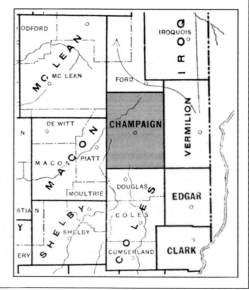

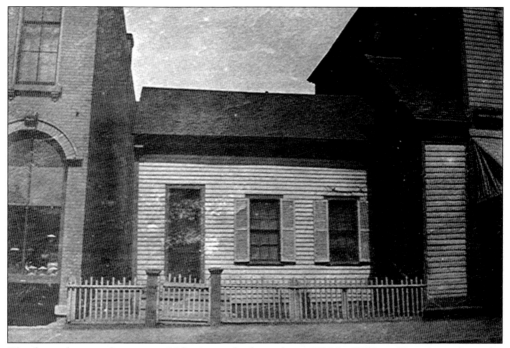

The first cabin in what is now Urbana was built in about 1822 by William Tompkins along the Boneyard Creek behind the present Courier Café. The cabin was a small, one-room dwelling built of hewn logs. In 1830, Tompkins was bought out by Isaac Busey, a Kentucky pioneer, who moved into the cabin with his family. On June 20, 1833, the cabin achieved great historic significance as the place where the location of Urbana was decided upon in an evening of merriment. After Busey's death, the cabin was moved to West Main Street a few yards south of its original location and was sided, as seen in the photograph above from about 1900. In 1902, the cabin was moved to Crystal Lake Park where it burned down in the 1950s. The photograph below shows the original location of the cabin in the early 20th century.

This map shows the original town of Urbana, platted on September 3–4, 1833. The town was established on 43 acres of land donated for this purpose by three of the largest land-holding families in the Big Grove. Kentucky pioneer Isaac Busey and his wife, Sarah, donated 30 acres, and Matthew W. Busey, Isaac's nephew, donated 3 acres. Isaac's old neighbor from Shelby County, Kentucky, Thomson R. Webber, acted as agent for his father, William T. Webber, who had purchased land in the Big Grove but was still living in Kentucky, and signed a deed for 10 acres. Each of the three families had its cabin along Main Street a few hundred yards apart. The new town consisted of a total of eight streets and a central square reserved for the county courthouse. The original east–west streets were Water, Main, Elm, and Green Streets, and the original north–south streets were Vine, Walnut, Market (now Broadway), and Race Streets. The streets were separated by alleys running east–west (Goose, Fish, and Cherry) and north–south (Grape, Thorn, and Crane).

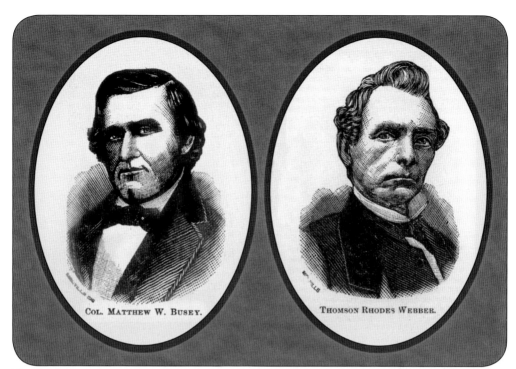

Col. Matthew W. Busey. Thomson Rhodes Webber.

Two leading pioneer politicians in Urbana were Matthew W. Busey and Thomson R. Webber. Busey (left), while a resident of Indiana, entered land in the Big Grove in 1832 and settled in Urbana in 1836. Here he became one of the largest landholders and stockbreeders and held the office of assessor. He and his family resided in the cabin he had built at 504 West Main Street. After the Civil War, two of his sons, Samuel T. and Simeon H., established Urbana's oldest still-functioning business, Busey Bank. Webber (right), a native of Shelby County, Kentucky, moved to the Big Grove in 1833. He became a leading politician in Urbana upon the city's establishment. He was the city's first postmaster and first clerk of both the circuit and county courts, holding the latter positions for 25 years. He was also master in chancery of the circuit court for 40 years. He built the first building in the original town of Urbana, which stood across from the courthouse at the northwest corner of Elm Street and Broadway.

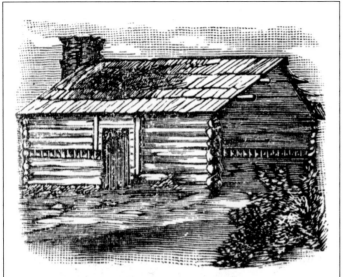

FIRST SCHOOL HOUSE.

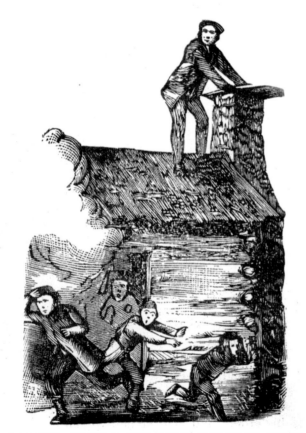

ASAHEL BRUER SMOKING OUT THE BOYS

This log building, located two miles east of downtown Urbana, was the first schoolhouse in the Big Grove. The tiny windows were covered with greased paper, and the seats were roughly hewn slabs. In 1832 and 1833, Asahel Bruer taught school here, and his story of smoking the boys out was long remembered by Urbana's old-timers. The first Christmas he taught school, he treated his students, among whom there were some older boys, to a bushel of apples and a gallon of whiskey, according to tradition, but the second Christmas he came empty handed. His students barred the door when he arrived, demanding their treat. He refused and climbed to the rooftop where he covered the chimney. The smoke from the open fireplace below soon sent the students flying out, who then got hold of their teacher and rolled him in the snow while pulling on his hair. Thereupon Bruer produced the apples and whiskey that he hid nearby, declaring that he was merely testing whether his scholars had any "real Kentucky blood" in them.

In the 1830s, all buildings were constructed of hewn logs, clapboards being too expensive to haul to pioneer settlements. The first courthouse, constructed in 1836, was such a log building and so was the first jail, pictured here. Built in 1840, the jail had an outside staircase to the second floor where its only entrance was located. Prisoners were lowered to the first floor from here through a small trap door.

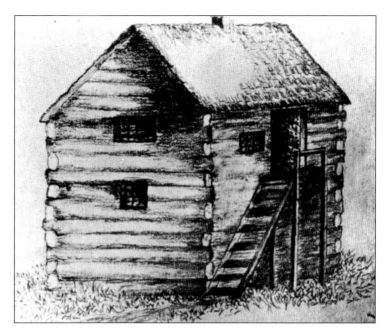

Urbana's first brick house, located on the southeast corner of Elm Street and Broadway, was built in 1841 by Arthur Bradshaw, a pioneer Methodist minister. The bricks used in the construction were the first manufactured in Champaign County, having been produced in the Cox Brothers's brickyards, located where Broadway crosses the Boneyard Creek. The house was torn down in 1913 for the historic bricks, sold at $1 a piece by the owner.

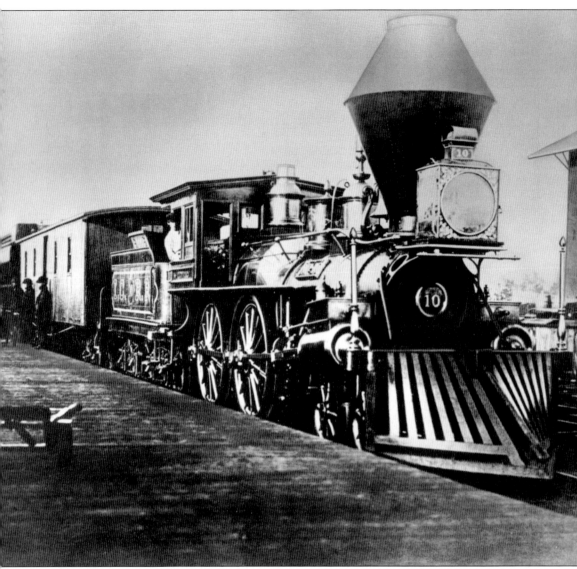

Urbana's urbanization was initiated by the Illinois Central Railroad, chartered in 1850. The railroad was to connect Chicago in northeastern Illinois to Cairo in the southern tip of the state. The route between Chicago and Urbana was finished in 1854, and the first locomotive, which very likely looked like the one on this photograph, rolled into the Urbana depot on July 24.

Two

THE RAILROAD
IS COMING
1850–1860

After a slow start, Urbana got on the fast track with the arrival of the railroad. Construction of the Illinois Central Railroad, the first to run through Champaign County, began in 1851, and the tracts connecting Chicago to Urbana were finished by July 1854. The construction and arrival of the railroad resulted in a population explosion and economic boom. Between 1850 and 1860, Champaign County experienced its historically largest population increase, a rise from 2,645 to 14,629 people (or 553 percent). Population composition also changed. The southern subsistence farmers of earlier decades were replaced by big-time land speculators, merchants, and intellectuals from the East. Masses of laborers employed in the construction and operation of the railroad and in the emerging construction businesses also poured in.

As the population grew, the town expanded. In the 1850s, its size quadrupled, and on February 14, 1855, Urbana incorporated as a city. Residential expansion first occurred to the southwest of the original town on the former Isaac Busey estate, which was subdivided and sold by his heirs after his death in 1847. Following the arrival of the railroad, a new town also grew up around the depot, built two miles west of Urbana in raw prairie land. Having direct access to the railroad, West Urbana grew faster than its parent town, and in 1860, it incorporated as a separate city called Champaign.

In response to the population increase and the opening of markets by the railroad, Urbana experienced its first boom in production and construction in the 1850s. The town's northwestern outskirts along the Boneyard Creek became the city's industrial area where a variety of factories sprung up overnight. Main Street became a hub of activity, lined with retail stores, saloons, law offices, banks, and real estate offices. In 1848, the small, second courthouse was moved from the public square and replaced by an attractive two-story brick and wood building that served the county during Abraham Lincoln's visits to the city as circuit lawyer in the 1850s. Urbana's first high school, first brick church, and first brick jail were also built during this decade. The first newspaper was published in September 1852.

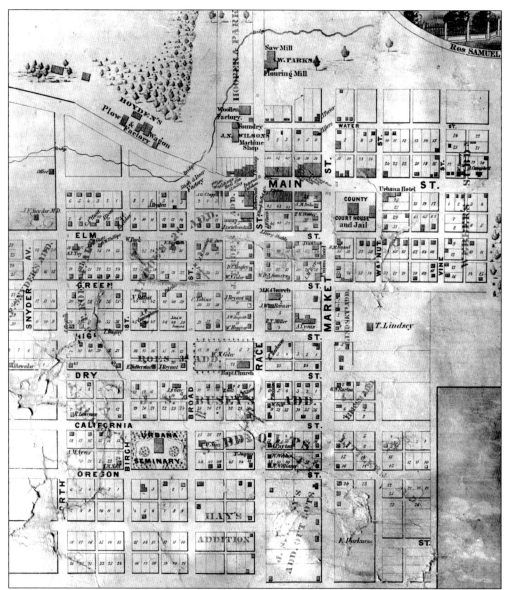

The first map of Urbana was created in 1858 by Alexander Bowman, an architect and surveyor. The above detail shows most of the city as it appeared on the map. By the end of the 1850s, the size of the original town more than quadrupled by the addition of over a dozen new residential subdivisions to its west and southwest. The public square was occupied by the third Champaign County Courthouse and the second jail. The city's oldest hotel, the Urbana Hotel, stood across from the courthouse on the southeast corner of Main and Walnut Streets. Main Street has become a commercial hub lined with over 40 business buildings. By 1858, the city also had several major factories just northwest of downtown in the Boneyard Creek bend. The oldest of these was William Park's sawmill and flouring mill, built in 1850 on Race Street by the Boneyard Creek bridge. South of it were a woolen factory and J. N. Wilson's Machine Shop, and west of the Boneyard Creek along Main Street was Ezekiel Boyden's plow and wagon factory.

The third Champaign County Courthouse depicted in this pencil sketch made by Henry Munhall was a two-story brick and wood structure with a bell tower in the center of the roof. It was built by Decatur contractors Edward O. Smith and Benjamin Dillehunt in 1848 and 1849 on the public square. Abraham Lincoln, as circuit lawyer, conducted many court cases in this building between 1849 and 1959.

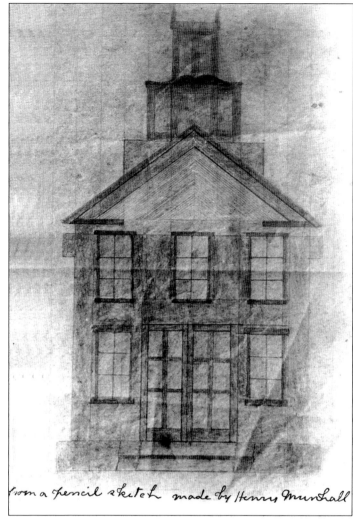

from a pencil sketch made by Henry Munhall

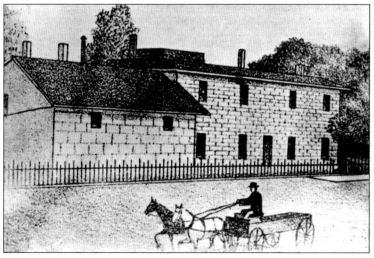

Urbana's second jail, built in 1856, was a much more substantial structure than the first log jail. This two-story brick building stood directly across from the courthouse along the east side of the public square, as seen on Bowman's 1858 map. This spatial arrangement of the courthouse and jail was retained until the 21st century.

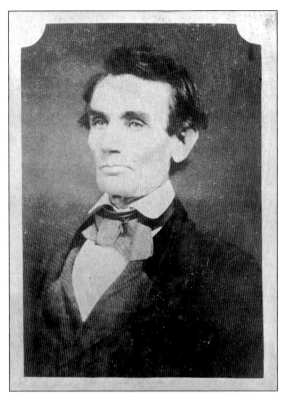

This picture of Abraham Lincoln was taken by Urbana photographer Samuel Alschuler on April 25, 1858, on one of Lincoln's visits to the city. Lincoln was a frequent visitor to Urbana as circuit lawyer on the Eighth Judicial Circuit, which included Champaign County. While in Urbana, he often stayed at the Pennsylvania House (below), across from the courthouse. This was Urbana's oldest hotel, originally run by Asahel Bruer under the name Urbana House. The core of the building was the first Champaign County Courthouse, a small log edifice that Bruer purchased in 1841 and sided it before he turned it into the hotel. Over the years, the hotel was expanded and had several owners. One of these was Samuel Waters, a Pennsylvania native, who became famous for his footrace with Lincoln down Urbana's Main Street.

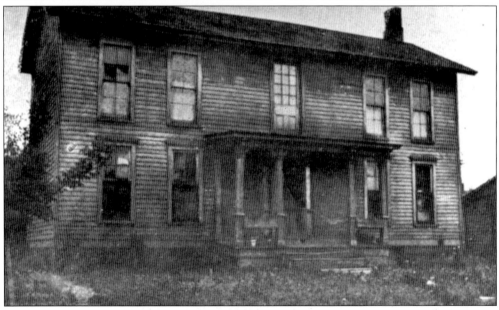

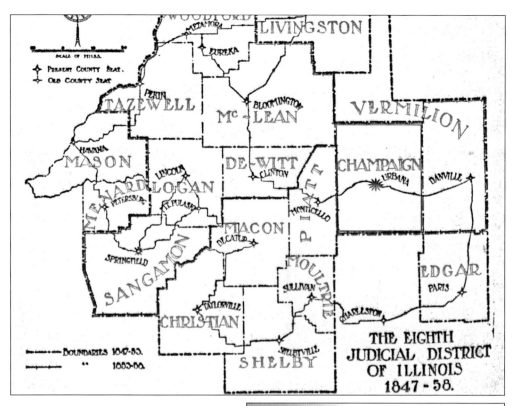

The Eighth Judicial Circuit included several counties in central Illinois, among them Champaign County. These counties were served by attorneys and judges from Springfield, the capital city, who presided over legal cases at the county courthouses, traveling in a circuit from county to county in the spring and fall. Lincoln traveled this route between 1847 and 1859 with Judge David Davis and other attorneys who became close friends of his over the years. One of these men was Henry Clay Whitney, who came to Urbana in 1854 with his father and became the first lawyer of West Urbana (Champaign). A result of his friendship with Lincoln was his book *Life on the Circuit with Lincoln*, published in 1892. The book includes many entertaining stories about Lincoln's visits to Urbana and about the hardships and delights of the circuit life.

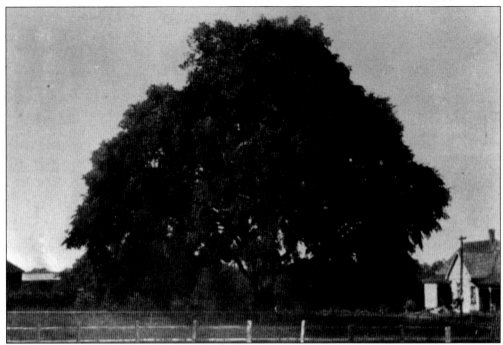

Lincoln is said to have given a speech under this giant elm tree, a remnant of the Big Grove, that had once stood in the yard of James Munhall and his wife, Nancy, at 704 East Main Street. This location was originally part of the large Webber estate of East Urbana, owned by Kentucky pioneers William T. and Nancy Webber and inherited by their daughter Nancy Munhall.

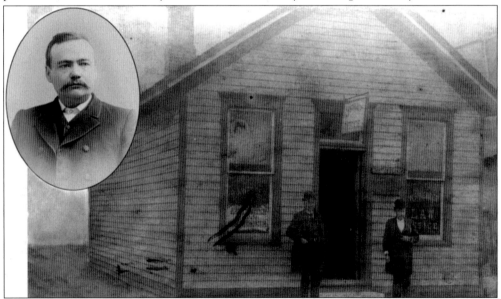

This small, single-story frame building, photographed in 1893, housed the law office of William B. Webber (inset), a well-known early Urbana attorney and son of Urbana pioneer Thomson R. Webber. William was instrumental in drafting and securing passage of drainage legislature, which was of great importance in transforming the surrounding wet prairies to farmland. From 1893 to 1895, he served as the mayor of Urbana.

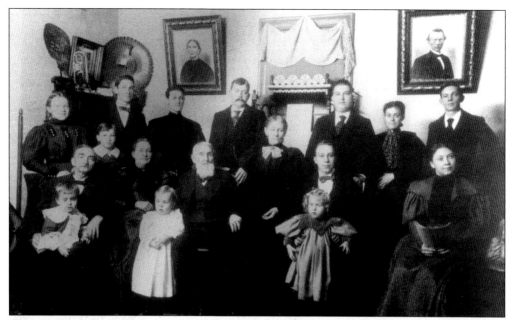

This photograph was taken around 1897 of some of the descendants of Thomson R. Webber. On the wall behind the seated family members are the pictures of Thomson and his second wife, Anna Burk Carson Webber. Seated on the left side is their son Robert Augustine Webber, and next to him is his wife, Eliza Waller Webber. The old gentleman in the middle is Eliza's father, Jonathan Cox Waller. (Courtesy of Carl Webber.)

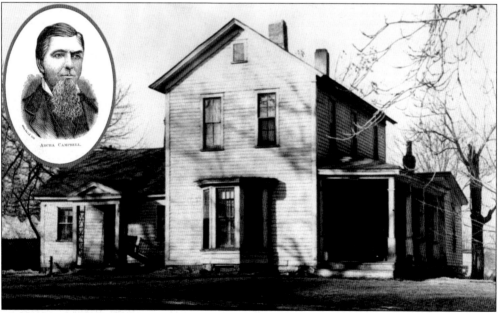

Urbana incorporated as a city on February 14, 1855. On June 2, Archa Campbell (inset) was elected the first mayor and served one year. Prior to this, Campbell also served as county commissioner and built, named, and operated the Doane House, West Urbana's first railroad station and hotel. He resided at 308 East Main Street in the house shown in this photograph from the 1960s, when the building was torn down.

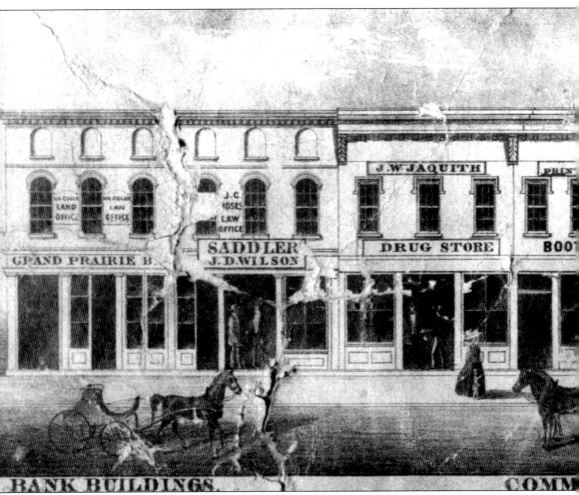

This early Urbana business block, depicted on the 1858 Alexander Bowman map, was built in the early 1850s on the north side of Main Street between Crane Alley and Market Street (the present Broadway). The building on the corner of Main Street and Crane Alley housed the law and real estate office of William H. Coler and his Grand Prairie Bank. Next came J. D. Wilson's saddler shop and Jesse W. Jacquith's drugstore. Jacquith was Urbana's third mayor, serving his

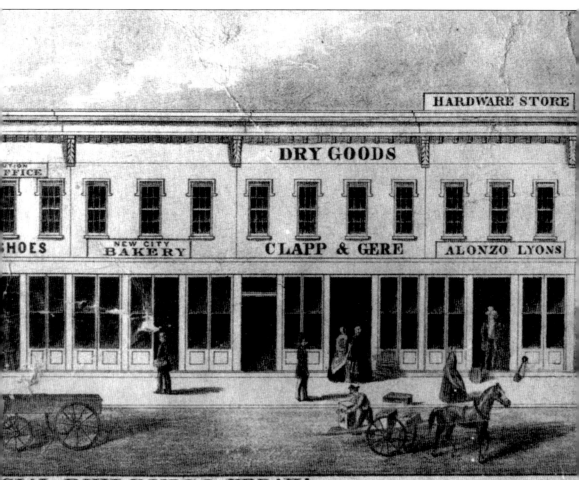

HARDWARE STORE

DRY GOODS

CLAPP & GERE

ALONZO LYONS

NEW CITY BAKERY

HOES

UTION FFICE

CIAL BUILDINGS. URBANA

term at the time this image was made (between 1857 and 1858). The next building housed a boot and shoe shop and the printing house of the *Constitution*, the second newspaper published in Urbana. Additional businesses on the block included Clap and Gere's dry goods store, Alonzo Lyons's hardware store, the New City Bakery, and J. C. Moses's law office.

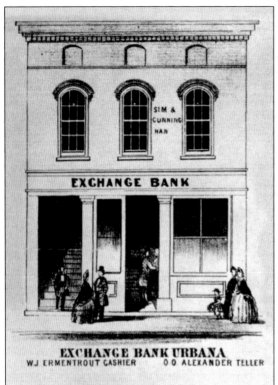

EXCHANGE BANK URBANA
WJ ERMENTROUT CASHIER O O ALEXANDER TELLER

Urbana's first corporate bank, the Grand Prairie Bank, opened in March 1856 on the corner of Main Street and Crane Alley in a two-story brick building constructed in 1851. William H. Coler was president, and Thomas S. Hubbard was cashier. It was the successor of Urbana's first bank, a private lending institute opened by Hubbard in 1855. In June 1856, the Grand Prairie Bank opened the Cattle Bank, a branch office, in West Urbana (now Champaign) near the new railroad station. Coler, Hubbard, and J. D. Wilson were directors, and Edward Ater, Champaign County judge, was the president. Both banks prospered until 1861, when a financial crisis lead to their collapse and permanent closing. In 1862, Thomas S. Hubbard, W. J. Ermentrout, and William Harvey opened a new bank, the Exchange Bank, in the building of the former Grand Prairie Bank.

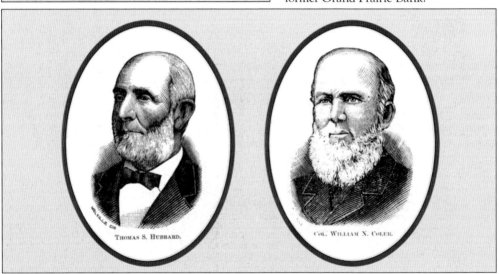

THOMAS S. HUBBARD. COL. WILLIAM N. COLER.

The so-called Brick block was another early business section in Urbana built on the southwest corner of Main and Race Streets in the early 1850s. It consisted of two buildings, each three stories high. The one directly on the corner housed Eli Halberstadt's grocery on the ground floor. In the 1860s, he established grain storage and the Union flouring mill behind the present Courier Café.

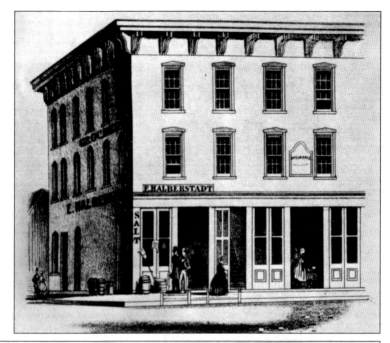

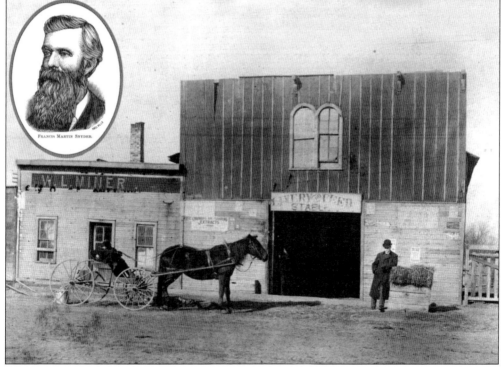

The first newspaper in Champaign County, the *Urbana Union*, was published on September 25, 1852, by William C. Coler and H. K. Davis. In 1853 and 1854, the printing office was located at 115 West Main Street in the small building shown on the left of the photograph. Printing was done by Frank Snyder, Urbana's first practical printer and later owner and publisher of the newspaper the *Republican*.

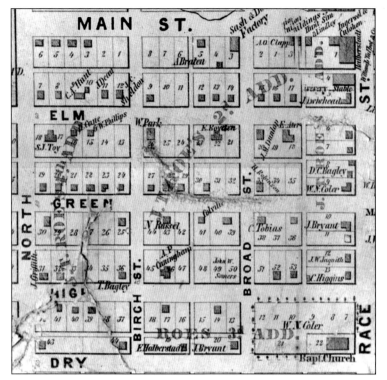

Urbana's first residential subdivisions were made by James T. Roe, farmer and son-in-law of Urbana pioneer Isaac Busey. After Busey's death in 1847, his properties west of the original town of Urbana were inherited by his daughter Lillis and her husband, James T. Roe. The 1850 chartering of the Illinois Central Railroad opened the opportunity for financial gain, and between 1850 and 1854, Roe made four subdivisions between Race and North (now McCullough) Streets.

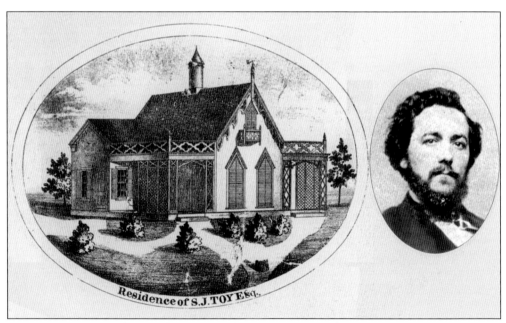

Residence of S. J. TOY Esq.

In the mid-1800s, Urbana's Elm Street, which ran along the south side of the courthouse square, became one of the most sought-after residential streets of the city. Politicians, attorneys, physicians, and factory and store owners built their residences along it. One of these people was Solomon J. Toy, whose house stood at 409 West Elm Street. Toy was the Champaign County clerk between 1857 and 1865.

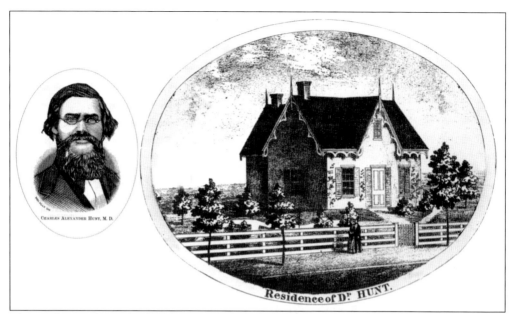

The residence of Dr. Charles A. Hunt, surgeon and physician, stood at 408 West Elm Street. He came to Urbana in 1855 and worked as druggist on Main Street. Between 1859 and 1861, he was mayor of Urbana, and he played a key role in getting the University of Illinois located here. He participated in the Civil War, where he worked himself to death saving other people's lives.

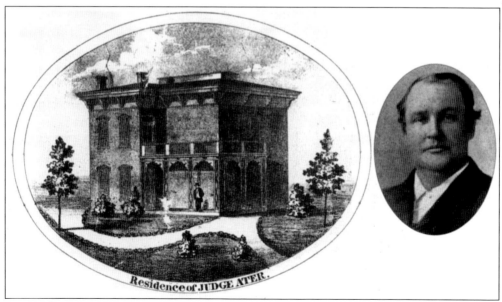

One of the very rare early brick houses in Urbana stood at 209 West Elm Street in downtown. It was built in the 1850s by Judge Edward Ater, a leading Urbana politician. In 1866, the house was purchased by attorney Francis G. Jaques, who is known as the founder of the Urbana Public Library. The Jaques house was demolished in 2001 for the expansion of the library he founded.

The area west of James T. Roe's additions was subdivided by Urbana lawyer Joseph W. Sim and by Dr. Jacob F. Snyder, an early Urbana physician and father of printer and publisher Frank Snyder. Sim's and Snyder's additions remained a quasi-green belt on the western outskirts of town occupied by a few large estates, including their own. Snyder built his residence in the 500 block of Elm Street, which later became home to two Urbana mayors, Clark R. Griggs and Royal A. Sutton. Sim built his two-story brick residence (below) on a large estate in the 600 block of Green Street. He came to Urbana in 1853 and married Sarah Ann Busey, daughter of Urbana founder Matthew W. Busey. He worked as attorney, was county judge for four years, and also served as Urbana mayor from 1864 to 1866.

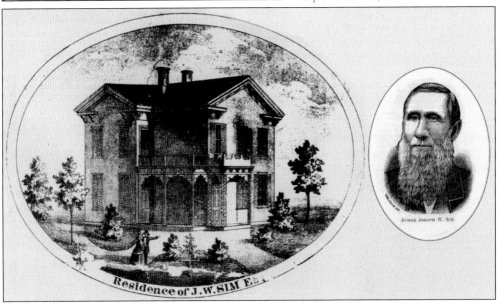

Residence of J.W. SIM Es.

JUDGE JOSEPH W. SIM.

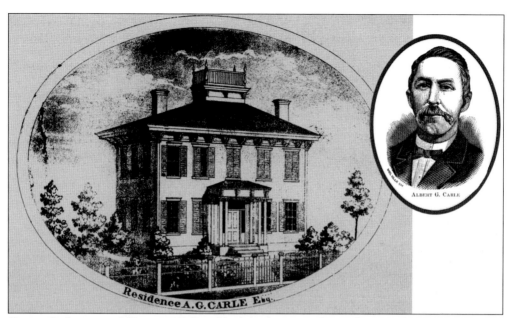

Residence A. G. CARLE Esq.

ALBERT G. CARLE

Gustav Carle came to Urbana in 1847 and built his home on the southern outskirts of town, where Carle Park now stands. He was a successful farmer and stockkeeper and for many years drove cattle to the New York and Philadelphia stock markets. After his death in 1881, his widow subdivided their large estate and donated part it for the establishment of a public park in his memory.

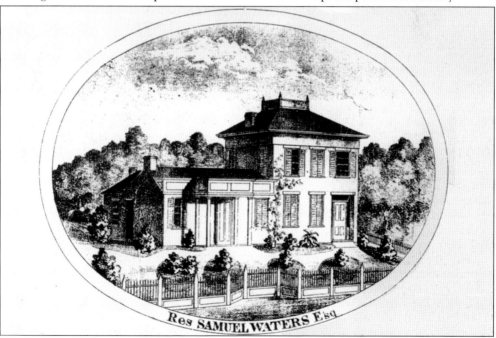

Res SAMUEL WATERS Esq

Another elegant residence built in the 1850s in Urbana was the home of Samuel Waters. Waters was a native of Pennsylvania and came to Urbana with his family in 1855. He purchased Urbana's first hotel, then known as the Urbana House, and renamed it Pennsylvania House after his home state. Under his management, the hotel became the city's most popular hostelry, which often hosted Abraham Lincoln on his circuit trips.

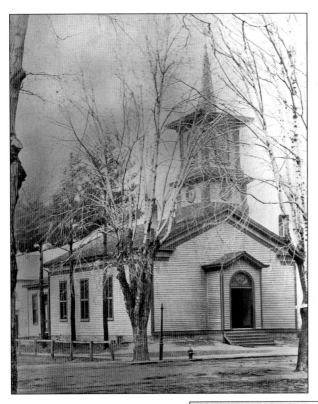

The earliest religious denominations organized in Urbana were the Baptist and Methodist Episcopal congregations. The Baptist congregation built its first church in 1855. This small, one-story frame structure stood on the northwest corner of Race and Illinois Streets, where the Baptist church still stands. This building was moved in the late 19th century to the grounds of the present Leal School and was used as a school for the lower grades.

The first church in Urbana was a small frame structure on the south side of Elm Street between Race Street and Broadway, erected by the Methodists in 1841. In 1856, the building was sold and converted to a livery stable. The building shown here was the second sanctuary, constructed in 1856 at the southeast corner of Green and Race Streets. This late-19th-century photograph shows the building with a later tower.

Urbana's first high school, the Urbana Male and Female Seminary (seen here), was constructed in 1855 by the Methodist church. It stood on the block between Oregon and Ater (now Nevada) Streets and Birch and Broad (now Cedar) Streets, where the present Leal School stands. The school was built of brick in the typical neoclassical revival style of the contemporary churches, like the second sanctuary of the Urbana Methodists.

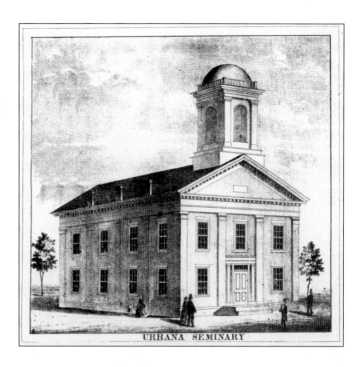

URBANA SEMINARY

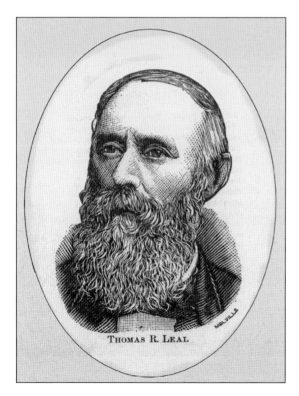

THOMAS R. LEAL

The Urbana school system was reformed by Thomas R. Leal, who came to town in 1852, and was school superintendent between 1857 and 1873. His office was located in the high school building above, and one of Urbana's present school districts is named after him.

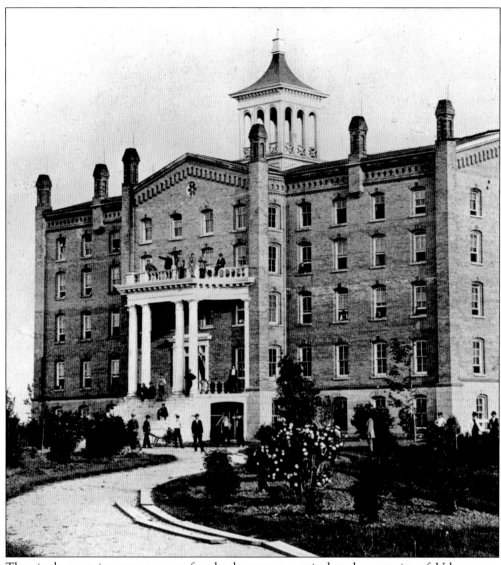

The single most important event for the long-term survival and prosperity of Urbana was the establishment of the Illinois Industrial University, the state's first land grant college. The university was chartered in 1867 by the Illinois legislature and opened for teaching in September 1868. In 1885, the university's name was changed to University of Illinois—its current name.

Three

URBANA WINS
A UNIVERSITY
1860–1880

The years after the Civil War were a time of fast growth. The decade's most important accomplishment was the establishment of the Illinois Industrial University, later renamed University of Illinois. Under the brilliant leadership of Urbana mayor and state representative Clark Robinson Griggs, the highly contested location for the newly chartered Illinois Industrial University, the state's first land grant college, was decided in Urbana's favor. It was a decision that ultimately secured the city's survival and prosperity. Started in a single building in barren prairie land between downtown Urbana and Champaign, by the late 1870s, the university expanded by three large, new buildings and began to earn a reputation for pioneering scientific work.

The same year that Griggs championed the university, he also secured a charter for the Danville, Urbana, Bloomington and Pekin Railroad (later known as the Indiana, Bloomington and Western Railway and the Big Four). It was the first railroad to pass through Urbana and, for the next five decades, was the city's largest employer. The line was completed in 1869, and in 1870 and 1871, it located both its headquarters and repair shops in Urbana, the latter just north of Main Street in East Urbana. Seeing the opportunity in the railroad, the extensive Webber holdings in East Urbana were subdivided and sold off as city lots starting in 1872. The area was quickly built up with small cottages that became home for the hundreds of workers employed by the railroad and in the burgeoning construction industry. East Urbana was put on the map as a neighborhood of working-class people.

On October 9, 1871, the same day Chicago was burning, most of downtown Urbana was also destroyed by fire. The subsequent rebuilding created Urbana's most elegant downtown yet, composed of fashionably designed two- and three-story brick business blocks. Main Street was paved with brick for the first time, the streets were lit by gaslight, and the twin cities were connected by a mule-drawn streetcar. Not all was business, however. In 1870 and 1871, the citizens' cravings for music and play were satisfied by the construction of two Main Street opera houses, and intellectual curiosity was met by the establishment of the Urbana Public Library.

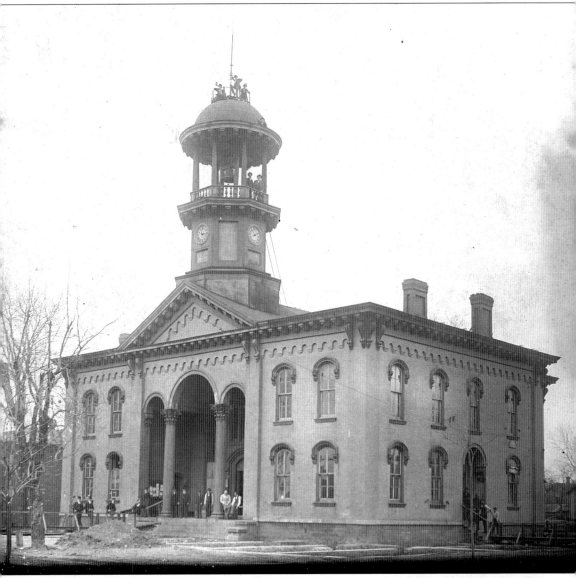

The new decade started with a new courthouse. Constructed in 1859 and 1860, the new courthouse was not built out of necessity but rather as a symbol of Urbana's resolve to keep the county's political control in its hands. By the late 1850s, Urbana's twin city, West Urbana, which grew up spontaneously around the Illinois Central Railroad depot two miles west of Urbana, was seriously considering seceding from Urbana and incorporating as a separate and independent city. Being significantly stronger than Urbana economically and having a much larger population, there were even voices calling for the establishment of West Urbana as Champaign County's judicial seat. To stem these aspirations, Urbana quickly built a large, new courthouse. The plan worked—Urbana remained the county seat. In April 1860, following popular vote, West Urbana incorporated as a separate city, calling itself Champaign.

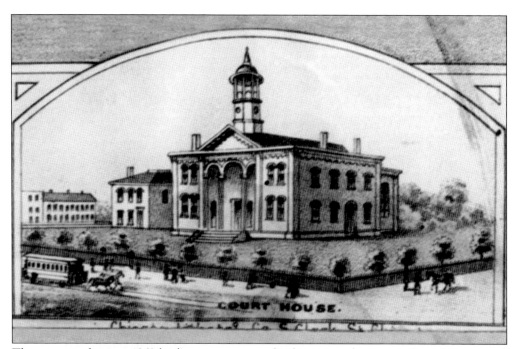

This vignette from an 1869 bird's-eye view map of Urbana provides an excellent perspective of the buildings associated with the city's public square at the time. In the center of the square is the new Champaign County Courthouse followed by the Champaign County jail along the eastern border of the square. In the distance is the Pennsylvania House, Samuel Waters's famous hotel, where Abraham Lincoln stayed on many occasions. In the foreground is the new street railway, built in 1863 by mill owner William Park, Archa Campbell, and capitalist Mr. Randall from New York State. Park later operated the railway with his son-in-law, attorney Francis G. Jaques, founder of the Urbana Public Library. The railway ran between the courthouse in downtown Urbana and the Champaign depot and was the first railway in Illinois outside of Chicago. Until 1891, when it was electrified, it was operated by a team of mules.

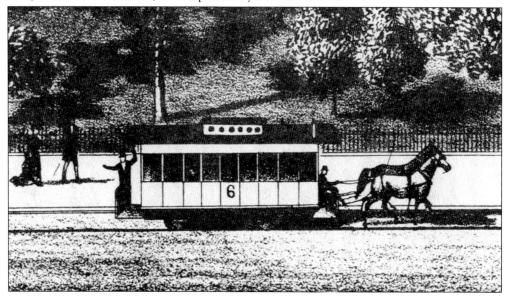

URBANA & CHAMPAIGN INSTITUTE.

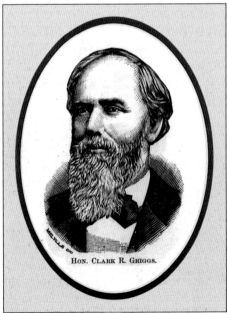

HON. CLARK R. GRIGGS.

In its first few years, the Illinois Industrial University operated in a towering, five-story brick edifice built in the early 1860s on the southeast corner of University Avenue and Wright Street. Generally known in its time as the Elephant, the building sat forlorn in the open prairie halfway between Urbana and Champaign and served all functions associated with teaching. In the four-year struggle for locating Illinois's first land grant collage in Urbana, a key role was played by Clark Robinson Griggs, an Urbana entrepreneur and maverick politician. At the 1867 meeting of the general assembly in Springfield, with $40,000 from the Urbana and Champaign townships, he entertained the Illinois legislators with oyster and quail dinners and provided cigars and theater tickets to entice them to vote for Urbana. The plan worked, and Urbana got the university.

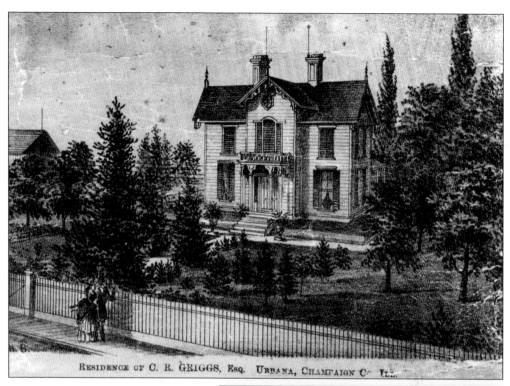

RESIDENCE OF C. R. GRIGGS, ESQ. URBANA, CHAMPAIGN C⁰ ILL.

A Massachusetts native, Griggs settled on Yankee Ridge, south of Urbana, in 1858, where he became a successful farmer. During the Civil War, he was a sutler with the Champaign County troops and successfully traded cotton from the South in his private ship along the Mississippi River. After the war, he moved to Urbana to start a political career. In 1866, he was elected Urbana mayor and representative in the Illinois General Assembly. He then maneuvered into the chairmanship of the Committee on Agriculture and Mechanical Arts, from where he had full control over the voting process on locating the university. In 1865, he purchased the late Dr. Jacob Snyder's estate in the 500 block of Elm Street and built a new residence (above), which stood at 504 West Elm Street. In the family photograph, he is seated with his wife, daughter, and grandson.

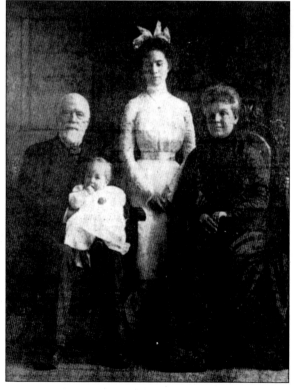

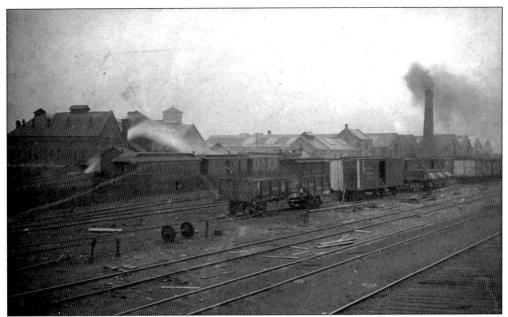

At the February 1867 meeting of the Illinois legislature, Clark Robinson Griggs succeeded in securing charters not only for the Illinois Industrial University but also for two other major projects—the Danville, Urbana, Bloomington and Pekin Railroad and the Champaign-Urbana Gas Light and Coke Company. Construction on the railroad began in 1867 with Griggs as president and was completed by 1869. The line brought great prosperity to Urbana not only by directly connecting it to the outside world and markets but also by providing jobs for hundreds of people in town. By the time of its completion, the railroad became part of the Indiana, Bloomington and Western Railway and later the Cleveland, Cincinnati, Chicago and St. Louis Railway, better known as the Big Four. The two images show the Big Four railroad yards in East Urbana around 1900. The lower picture shows the aftermath of an accident.

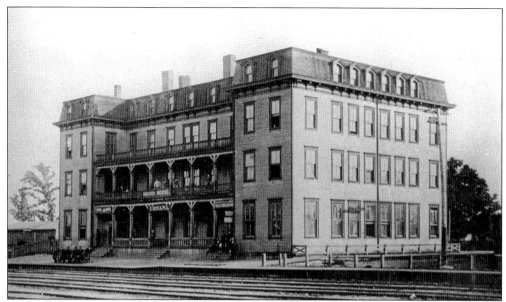

The railroad located its headquarters, shops, and roundhouse in Urbana. Its headquarters were in the Griggs House, a hulking, four-story frame building (above) constructed in 1870 between the railroad and the present Griggs Street east of McCullough Street. The building housed the railroad offices, passenger station, depot, a hotel, and a very popular restaurant. The railroad shops (below), a roundhouse, and rail yards were located in East Urbana between Maple and Glover Streets north of Water Street. The shops and roundhouse were substantial brick buildings constructed in 1870 and 1871 and served Urbana until the 1950s when the proliferation of cars lead to the dismantling of the entire railroad system and the demolition of the shops and roundhouse. The area is now occupied by Emulsicoat, an asphalt-processing factory.

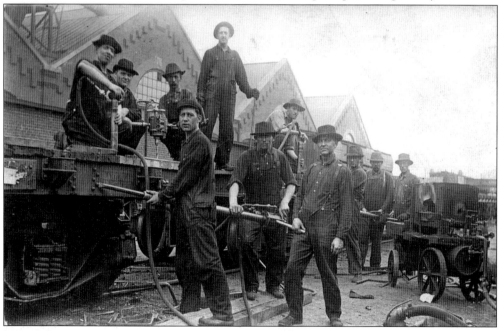

The hundreds of workers employed by the railroad settled nearby in East Urbana. One of these was Zachariah F. Sharp, who came to Urbana in the late 1860s to work on the railroad. He was the city's own Casey Jones, an engineer who lived through many exciting railroad adventures, including holdups, a derailing, and serious engine mishaps. Over the years, he was secretary, treasurer, and chief of the local chapter of the Brotherhood of Locomotive Engineers, and his adventures were frequently reported upon in the local papers. His lifelong residence was just four blocks south of the railroad yards, at 402 East Illinois Street. The photograph of the members of the Urbana Collage Lodge No. 501 of the Brotherhood of Railway Carmen of America was taken on Labor Day in 1914.

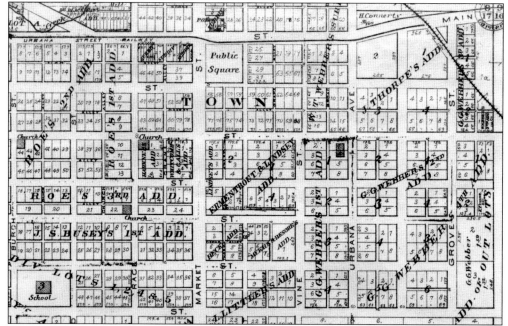

East Urbana owes its birth to the railroad. Prior to the establishment of the Danville, Urbana, Bloomington and Pekin Railroad (later called Big Four), the land east of Vine Street was the farmland and pasture of the Webber family. After their parents' death, George G. Webber (below, inset), son of early pioneer William T. Webber, bought out his siblings and became owner of the large Webber estate south of Main Street. The establishment of the railroad yards and shops in East Urbana in 1870 and 1871 provided the opportunity to subdivide his estate and sell it as city lots. During the 1870s, he made four subdivisions, known as Webber's additions (above), which were quickly built up with workers' cottages to accommodate the massive number of people employed by the railroad. In the early 1870s, he also built his own brick residence (below), which still stands at 605 East Main Street.

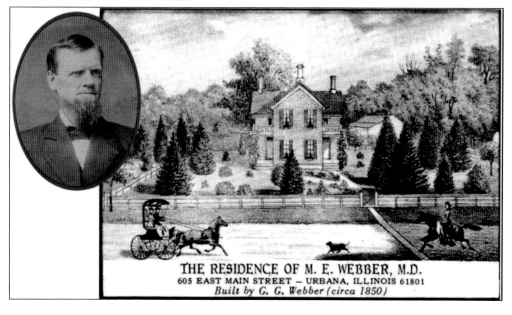

THE RESIDENCE OF M. E. WEBBER, M.D.
605 EAST MAIN STREET — URBANA, ILLINOIS 61801
Built by G. G. Webber (circa 1850)

45

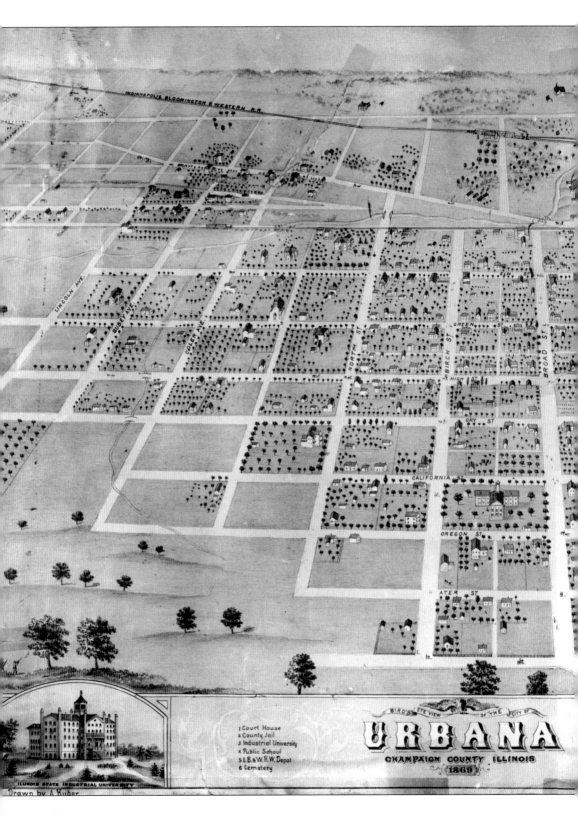

BIRD'S EYE VIEW OF THE CITY OF

URBANA

CHAMPAIGN COUNTY ILLINOIS
1869

1 Court House
2 County Jail
3 Industrial University
4 Public School
5 I.B. & W. R.W. Depot
6 Cemetery

ILLINOIS STATE INDUSTRIAL UNIVERSITY

Drawn by A. Ruger

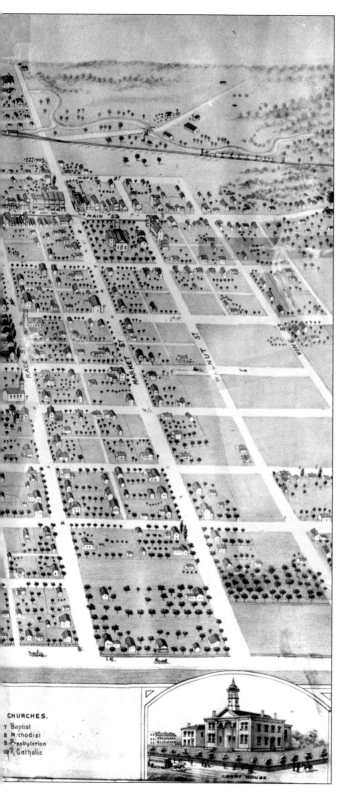

CHURCHES.

7 Baptist
8 Methodist
9 Presbyterian
10 R. Catholic

COUNTY HOUSE.

Although it was a very small town in 1869, when this bird's-eye view map was made, Urbana clearly had high aspirations. It had two rail lines cutting across town—the new Indiana, Bloomington and Western Railway, running in the northern part of the city across agricultural fields, and the local streetcar, running along Main Street and Railroad Street, carrying passengers across two miles of unimproved prairie between downtown Urbana and the Illinois Central Railroad depot in Champaign. In the middle of this prairie set the Elephant, the university's lone building, clearly visible in the map's northwest corner. The Boneyard Creek is crossed by six bridges, and the Saline Branch, in the northeast, is crossed by two. Main Street is lined with dozens of shops, and a number of factories are working in the Boneyard Creek bend west of Race Street.

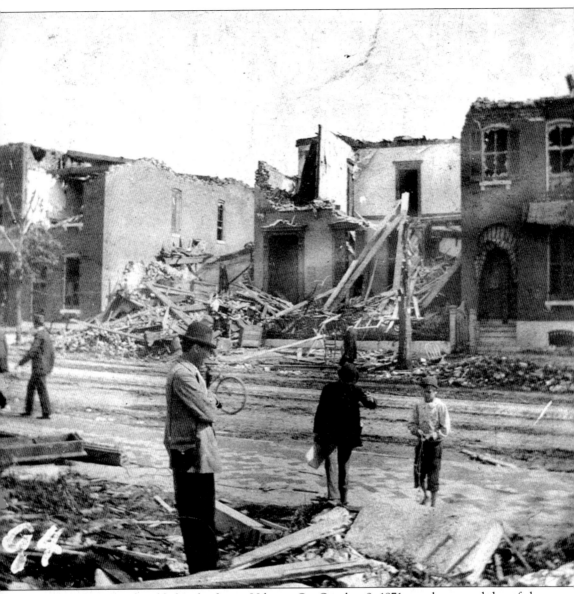

The 1870s were heralded in by fire in Urbana. On October 9, 1871, on the second day of the Great Chicago Fire, downtown Urbana was also burning. The fire started at about 2:00 p.m. at the stables of Mrs. Whitcomb and Hiram Shepard in the alley between Race and Market Streets (Broadway), two blocks south of Main Street. Due to an extremely strong southern wind, the fire quickly spread north and burned down several residences, barns, stables, and over 30 downtown businesses in its path. One of the residences was that of county clerk Thomson R. Webber, whose house was the first one built in the original town of Urbana. Alexander Spence's block on the southwest corner of Main Street and Broadway and his residence immediately behind it also burned down. From it, the fire quickly spread across the street to the former Grand Prairie Bank block, which was completely destroyed. This rare early image vividly depicts the fire's aftermath, very likely showing the Grand Prairie Bank block, which was the only brick block that burned in downtown.

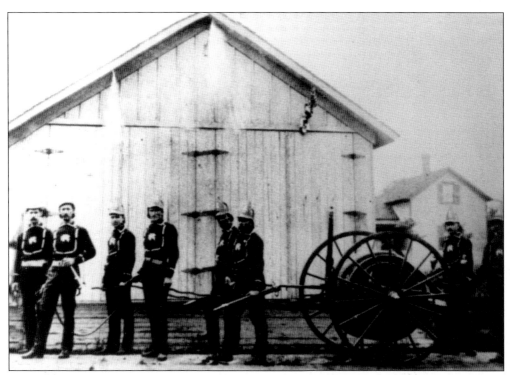

Images of early Urbana's firemen and their equipment illustrate the simplicity of firefighting techniques at the end of the 19th century. The firemen are standing in front of Urbana's first firehouse, located at 107 North Market Street (Broadway). Their interconnected harnesses indicate the firemen ran as a team to the site of the fire, and horses provided the power for the ladder wagon seen in the old photograph below. Within a few years, the city had built a brick fire station adjacent to the new city hall on Elm Street. Horses were not phased out of service until about 1913.

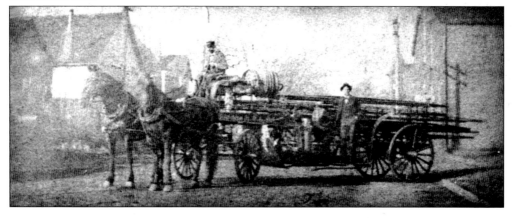

After the fire, the downtown business blocks were reconstructed with brick, larger and fancier than before and designed in the Italianate Revival style, the most popular style for business buildings at the time. One of the blocks entirely destroyed in the 1871 fire was the block of the Grand Prairie Bank on the north side of Main Street between Crane Alley and Broadway. The block was rebuilt in the summer of 1873 by Urbana carpenter and builder David Cantner and W. J. Ermentrout, the former owner of the Exchange Bank, which was housed in the building of the former Grand Prairie Bank. The new block consisted of three buildings (above), still functioning as business buildings today. The two buildings east of this block (below), on the northeast corner of Main Street and Broadway, were also built around this time.

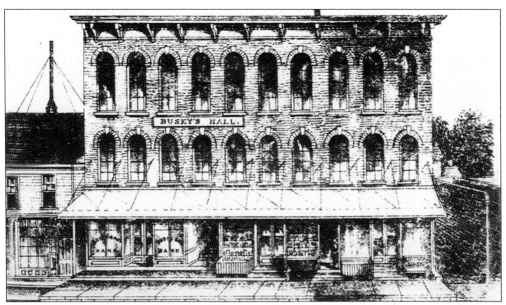

One of the buildings spared in the 1871 fire was the brick block constructed for the Busey brothers in 1870 by pioneer Urbana contractor and carpenter Zachariah E. Gill. Located on the north side of West Main Street west of Crane Alley, the building housed Busey's Bank, established in 1868 by Samuel T. and Simeon H. Busey, sons of Urbana pioneer Matthew W. Busey. The bank was located on the ground floor, while Busey's Hall, Urbana's first theater, occupied the second floor. The building is still standing with an art deco facade and houses the Cinema Gallery. Simeon H. and Samuel T. Busey were two of Urbana's most influential citizens, whose banking business is still flourishing. Samuel, shown on the right in his army uniform during the Civil War, was an Urbana mayor and city benefactor. Simeon (left) was a lifelong bank organizer and director.

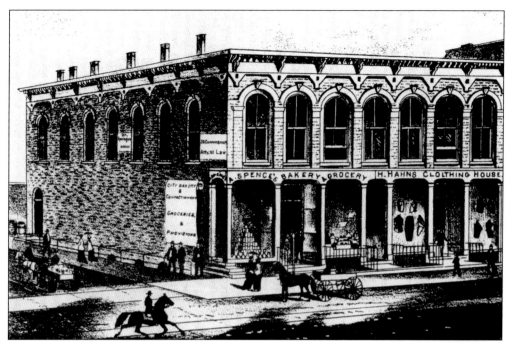

The Spence block, located on the southwest corner of Main Street and Broadway across from the Grand Prairie Bank block, was also destroyed by the 1871 fire. Owner Alexander Spence (shown below with his wife) was a native of Scotland, where he learned the trade of baking. He came to Urbana in 1858 and worked for George W. Burton, owner of the bakery on the southwest corner of Main Street and Broadway. In 1862, he bought out the bakery and added groceries and provisions. After the 1871 fire, he replaced his old store with a new, two-story building that housed his grocery and bakery, and H. Hahn's Clothing shop on the ground floor, and Joseph O. Cunningham's law office and Dr. Springer's medical office on the second floor. The block was torn down in 1970 following a fire in a neighboring building.

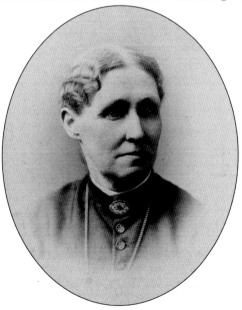
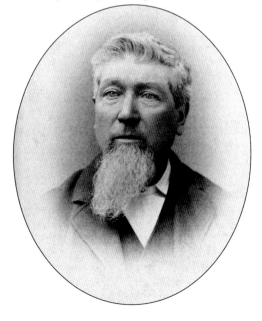

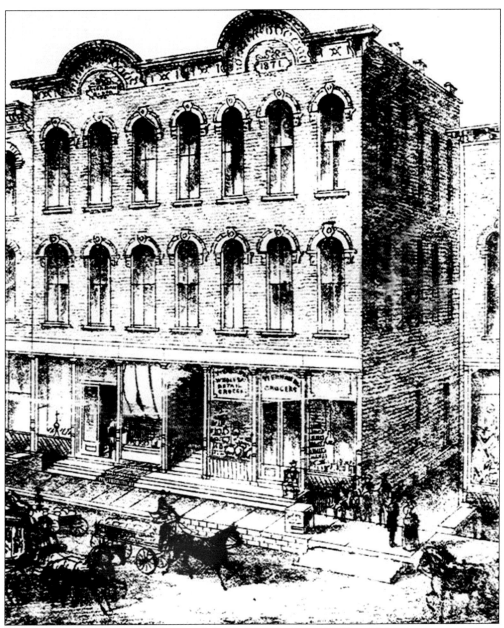

The Tiernan building, located west of the Spence block at 115 West Main Street, was built in 1871 for Frank Tiernan to house his grocery store. The store was located on the ground floor, while the top floor housed Tiernan's Hall, Urbana's second theater or opera house. Such opera houses produced a variety of shows, including vaudeville acts, musical performances, and operas and were also used as dance halls. Between 1873 and 1876, one of the rooms on the second floor was used as the first reading room of the Young Men's Reading Group, from which Urbana's public library evolved. The group was organized in 1872 under the leadership of Frank G. Jaques and Tiernan, and Tiernan provided the first reading room for its members in his spacious new building. Beginning in 1889, the building was owned by the Masons, who had a new facade built over the old one in 1914. The building is still standing and houses the Crane Alley restaurant.

Owned by Everett M. Knowlton and George M. Bennett, one of the city's oldest and longest-lived drug- and bookstores stood on the southeast corner of Main and Race Streets west of the Tiernan block. The store was established by E. Hyland Cushman in the early 1870s. Knowlton became an employee of Cushman in 1877 when he came to Urbana, and in 1885 he bought out his employer. He married George Bennett's sister and invited him to become his partner. Under their management, the store became one of Urbana's most successful and longest-lived businesses. This building (above) was replaced by a more modern one in 1926, which still stands. The image below was taken of the store's delivery cart

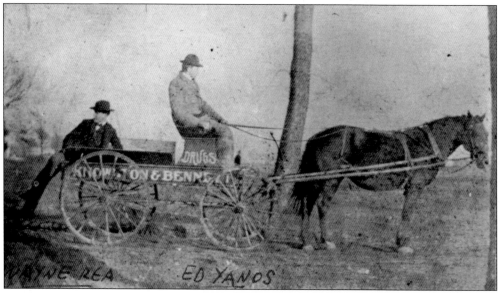

After the Civil War, two new church buildings were also added to Urbana. One of these was the first sanctuary of the First Presbyterian Church (seen here), built in 1866 and 1867. This small, frame structure stood at the northwest corner of Green and Orchard Streets until 1901 when it was replaced by a new brick building. Its founding members, all nearby residents, included Thomas S. Hubbard, Clark Robinson Griggs, W. M. Coler, Mrs. Jacob Snyder, Mrs. Charles Hunt, Thomas R. Leal, and W. J. Ermentrout.

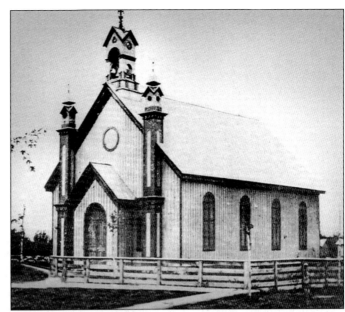

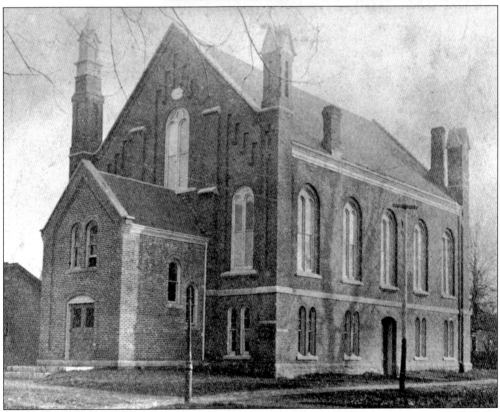

The Universalists, who have been meeting as a congregation since 1859, built their first sanctuary, this two-story brick building at 309 West Green Street, in 1870 and 1871. The front entrance vestibule seen in this photograph was a later addition. The church was demolished in 1913 to give way for a new edifice.

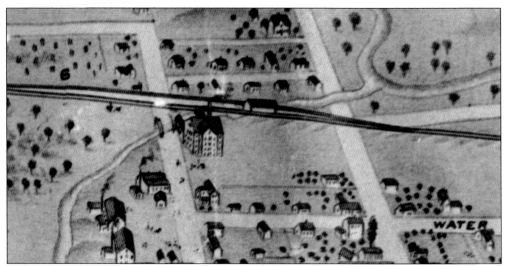

The high hopes and enthusiasm generated by the arrival of the railroad resulted in the construction of several major factories and numerous manufacturing shops in Urbana. Utilizing the Boneyard Creek, the first factories were built along its east bank just west of Race Street. One of the earliest industries was William Park's steam-powered flouring mill near the present intersection of Race and Griggs streets, built in 1850 (below). Other factories in the Boneyard Creek bend included a Woolen Factory, J. S. Wilson's Foundry and Machine Shop, both built in the 1850s, and Eli Halberstadt's flouring mill, the Union. Built in 1867, the mill stood on the lot of the former Isaac Busey cabin. The above section from the 1869 bird's-eye view map of Urbana depicts the city's factories in the Boneyard Creek bend, with Park's mill located southeast of the Boneyard bridge on Race Street at the intersection of the creek and the railroad.

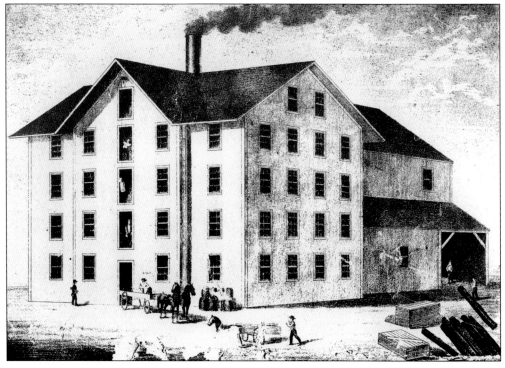

They always come back smiling because they are pleased with our

BRICK, SAND, CEMENTS, ETC.
and say, "Your Prices and Terms Just Suit Me."

THE OLD RELIABLE

SHELDON BRICK CO.
CALL OR WRITE
BOTH PHONES 18 NORTH WALNUT STREET

The mid-19th-century boom in construction created high demand for brick. Beginning in 1870, the county's main supplier was Urbana's Sutton and Sheldon Brick and Tile Factory located in the triangle between the railroads and Cunningham Avenue. The factory was established in 1855 by William Foote, a pioneer Urbana brick maker and contractor. Royal A. Sutton, an Urbana businessman, entered partnership with Foote in 1867, purchased the factory, and soon became known as the "Brick King of Champaign County." He later formed a partnership with his brother-in-law, C. C. Sheldon, who became sole owner after Sutton's death. Many of the early university buildings, churches, and downtown business blocks were constructed of bricks from this factory. The picture below is A. O. Howell's brick and tile factory, established in 1877, just north of Urbana.

EXTERIOR.

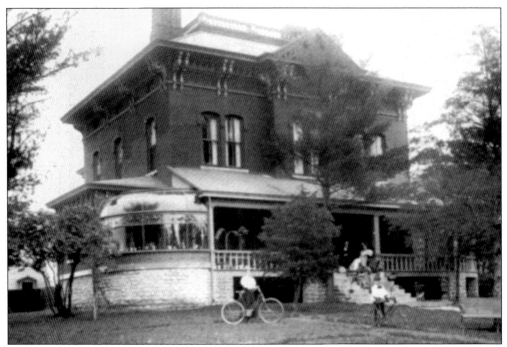

Samuel T. Busey, cofounder of Busey Bank, built his home at 504 West Main Street on land where his father's original cabin used to stand. After his father's death in 1852, Busey bought out large parts of the inheritance along Main Street from his siblings, and in 1873, he replaced his father's cabin with this elegant brick residence. In this image from about 1900, the original Italianate-style house is still visible behind the later Victorian porch additions. The photograph below commemorates a wonderful summer day with Busey and his wife, Mary, sitting in the back row on their home's front porch stairs surrounded by a happy group of people. This home was torn down in the 1970s for the construction of a large apartment complex.

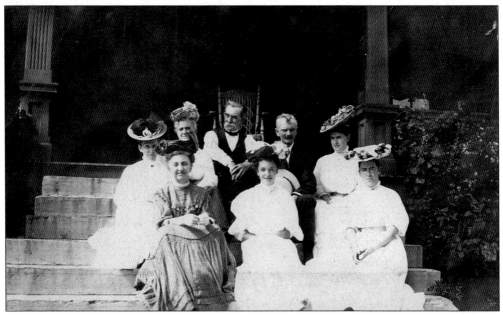

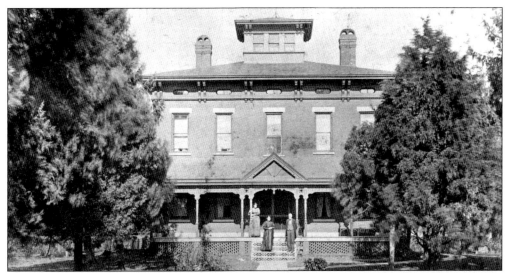

Simeon H. Busey, cofounder of Busey Bank, built his home along what is now University Avenue. The 1869 bird's-eye view map of Urbana shows the home as a lone building in the middle of extensive agricultural fields north of the railroad in the west half of the map. In this photograph from around 1900, Simeon and his wife, Artemisia, are standing in front of their stately, two story, Italianate-style brick home. This building was torn down in 1975 by Carle Hospital to make way for expansion. In the picture below, Simeon and Artemisia, seated at front center, are surrounded by their children. Seated with them are Ann A. Morgan and John W. Busey, and standing behind them from left to right are William H., Elizabeth F. Riley, Matthew W., George W., Alice J. Freeman, and James B. Busey.

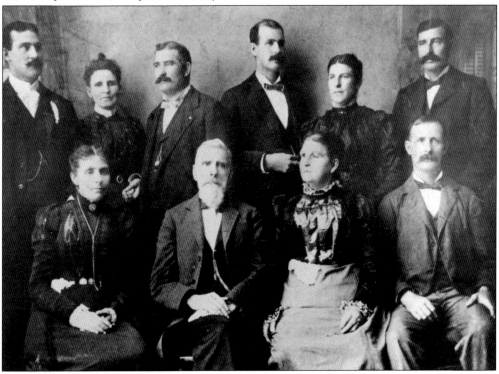

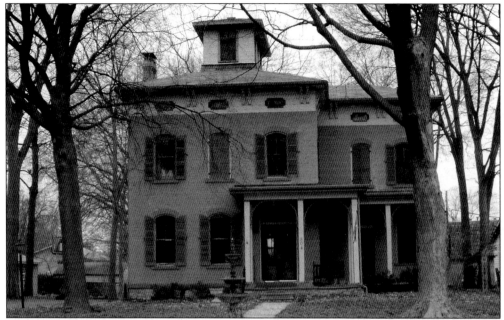

This elegant Italianate-style brick home at 804 West Main Street was built in 1868 and 1869 by Matthew E. Busey on land he purchased from Samuel T. Busey. Better known as "Black Matt" for his dark complexion, Matthew E. Busey was a cousin of Urbana pioneer Matthew W. Busey and the son of Matthew E. Busey Sr., who was the first Busey to settle in the Big Grove in 1829. This home was used as student rental in the mid-20th century and was condemned by the city. Subsequently it was restored by a family and is serving again as a private home. The pictures below show "Black Matt" Busey and his wife, Sarah. Sarah's picture was taken in Jerusalem, wearing the local costume.

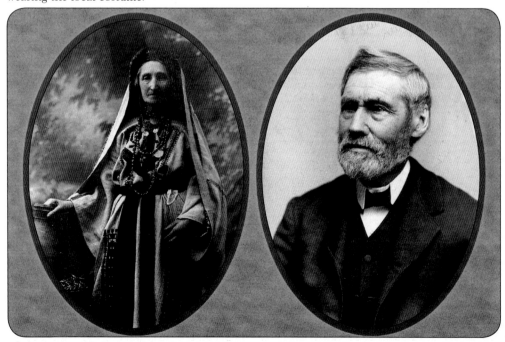

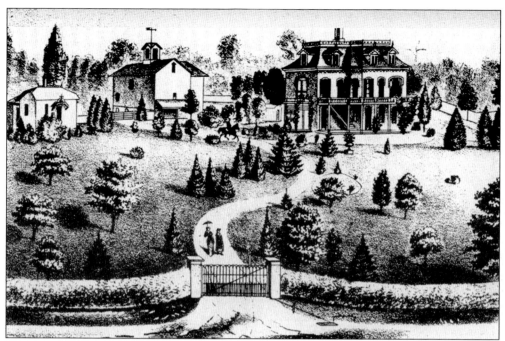

This stately home was built in 1869 by one of Urbana's best-known residents, attorney Joseph O. Cunningham. The estate stood on the northern outskirts of Urbana on the west side of Heater Street, which was later renamed Cunningham Avenue after Cunningham. A native of Lancaster, New York, Cunningham came to Urbana in 1853. In the same year, he purchased Urbana's first newspaper, the *Urbana Union*, and was its owner and editor until 1858. He held the office of Champaign County judge for four years and was a trustee of the University of Illinois. He was a founding member and vice president of the Illinois State Historical Society and an author of books on legal issues. He is best known for his *History of Champaign County* (1905), a definitive book on the subject. The pictures below are of him and his wife, Mary.

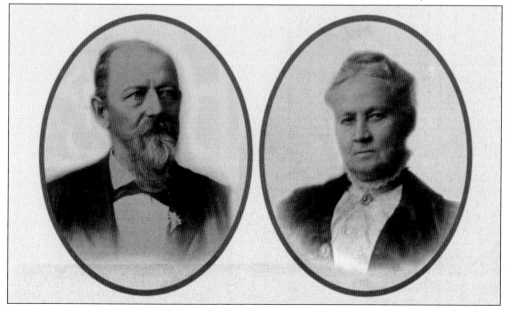

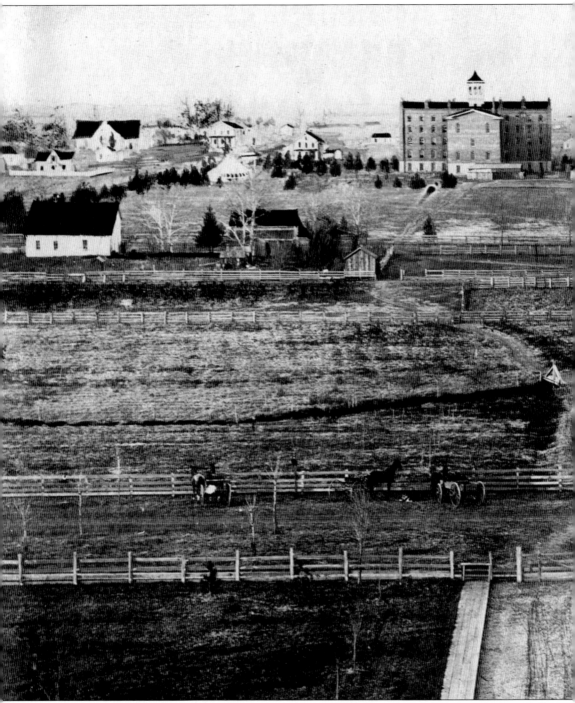

This photograph of the university campus taken in 1874 from the tower of University Hall, gives a good sense of the rural character of the university's early surroundings. The original university building, known as the Elephant, is in the back center of the picture, towering over the surrounding barren landscape. Its location corresponds to the present southeast corner of University Avenue and Wright Street. On its left side are scattered family homes. On the right

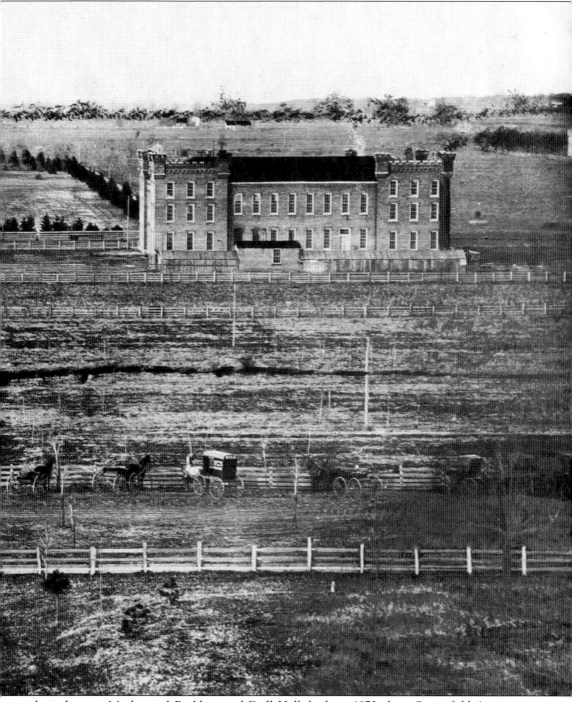

side is the new Mechanical Building and Drill Hall, built in 1870 along Springfield Avenue. With this building the campus began its move to the south towards the university farms. In the foreground is Green Street, then a dirt road, which was the main thoroughfare connecting Urbana, the university campus, and Champaign. A small bridge spans the Boneyard Creek in the middle of the picture.

The oldest building still standing on the university campus is the Farmer's House, now know as Mumford House after Prof. Herbert Mumford, its longest resident. This two-story frame building was constructed by the university in 1870 as a model residence for the contemporary farmer and served as home for heads of the agriculture department. Built south of Green Street in what was then the university farm area, the building is now surrounded by large, contemporary university buildings. Agricultural field experimentation started early at the university under the direction of Willard C. Flagg and Manley Miles, but long-term experiments began with George E. Morrow (below, inset), the first dean of the College of Agriculture. In 1879, he started experimenting with corn on a plot established by Miles in 1876. Now known as the Morrow Plots (below), it is the country's oldest permanent agricultural experimental station.

Among the first university faculty was Thomas J. Burrill, who was hired in 1867 to teach natural history and botany. He became a lifelong faculty member and made outstanding contributions to the early development of the university as president, administrator, and scientist. He also initiated a campus beautification program, planting thousands of trees and shrubs with his students, which had in time transformed the barren campus grounds to a pastoral environment. Burrill's experiments on apple and pear trees in the university orchards, for which he had purchased hundreds of trees, lead to his discovery of the bacterial cause of fruit blight, which established him as the founder of the science of plant pathology. Shown below in his laboratory with his students, Burrill was the first professor in the nation to use microscopes in botanical instruction.

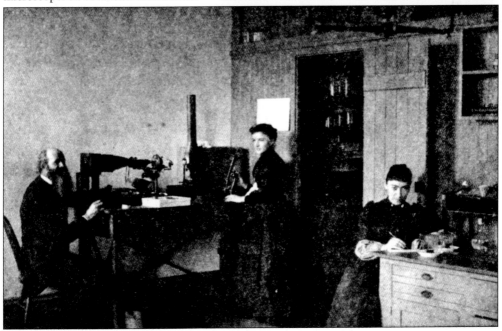

The university's first president, John M. Gregory (above, inset), was a humanist and wanted his students, most of whom were Illinois farm boys, to be educated not only in agriculture and mechanics but also in the fine arts. After his 1873 trip to Europe, he ordered dozens of casts of classical European sculptures to be shipped to the university for art education. His art gallery (above) opened in 1875 in University Hall. Most casts arrived in pieces, and Lorado Taft (below, inset), son of eccentric university professor Don Carlos Taft, spent a summer piecing them together, which started him on his carrier as nationally acclaimed sculptor. Lorado grew up in the house below on John Street (now by Mount Hope Cemetery on Pennsylvania Avenue) and after receiving his master of arts degree at the university in 1879, he studied at the Ecole des Beaux-Arts in Paris. (Above and Taft photograph, courtesy of the University of Illinois Archives.)

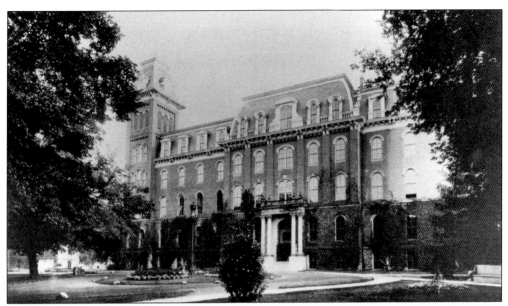

Following the construction of the Farmer's House and the Mechanical building, which were the first two structures erected by the university after its establishment, it next constructed University Hall (above), an elegant, large edifice that was to take over the functions of the original university building. Built at the east end of John Street in the center of the campus quadrangle, the building was dedicated in 1873. It served until 1938 when it was demolished to give way for the Illini Union building. Next in the line of major university construction was the chemistry building (now known as Harker Hall), shown below. Built in 1878 northeast of University Hall, this elegant, four-story building was designed by Nathan C. Ricker, the university's first graduate in architecture and longtime head of the Department of Architecture.

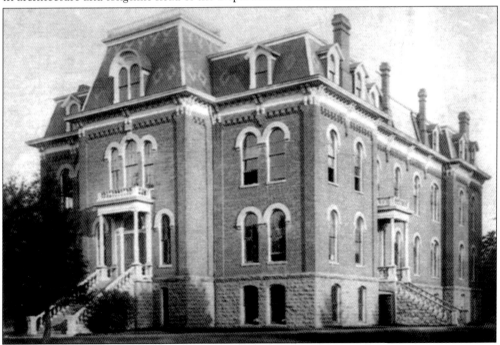

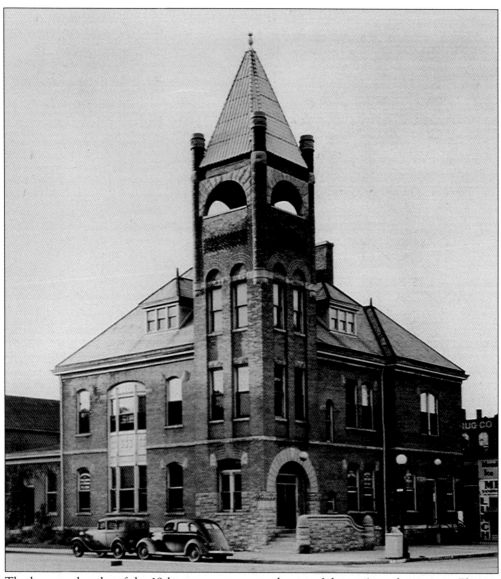

The last two decades of the 19th century represent the era of the city's modernization. Electric lighting, telephone lines, central water supply and a sewer system, street paving, and electrifying and expanding the city's public transportation system were all accomplished in these two decades. The new city hall, built in 1893, was a symbolic expression of the city's high aspirations and practical steps towards urbanization.

Four

PUTTING THE URBAN INTO URBANA
1880–1900

The fast-paced urbanization that started in the mid-19th century continued through the dawn of the 20th century, focused on modernizing the city's infrastructure. First in line was the telephone. Although a simple, telegraph-like local telephone system already existed by 1878, the more widespread use of telephones began in 1881 with the establishment of the Central Telephone Company. Drilling for coal in a get-rich-fast scheme along Urbana's Church Street in 1883 and 1884 resulted in an early central water supply system. Instead of coal, the entrepreneurs struck water, upon which they built the twin cities' first water works and, in 1885 and 1886, laid water mains in both cities. At the same time, a small electric plant was also established at the water works, and in the following years, electric lamps began to illuminate the twin cities' business districts.

Electricity was the name of the game at the dawn of the 20th century. By 1889, the twin cities' new luminary, William B. McKinley, had bought up and consolidated all the existing utilities and began the establishment of a far-reaching electric transportation system. In 1891, he electrified the former mule-powered street railway, which was by this time developed into a fine network of routes across the two cities and the university campus. Subsequently, he built east-central Illinois's first interurban railway, connecting the twin cities first to Danville (1902) and later to St. Louis via the bridge over the Mississippi River that he built for this purpose and named after himself. In the early 1880s, the twin cities were also connected to the state's first east–west railroad, the Great Western Railway, later known as the Wabash Railroad.

Symbolic of the great municipal improvements, in 1893, Urbana erected a fanciful brick city hall across from the county courthouse followed by a new brick fire station. Public education also came to the fore in the 1890s, with new grade and high schools established all across town. Kate Baker Busey opened the city's first kindergarten in her Elm Street home, and Joseph O. Cunningham and his wife, Mary, bequeathed their home of 25 years for the establishment of an orphanage. Well-to-do businessmen built magnificent Victorian mansions, and the former farmer university took on an urban aura.

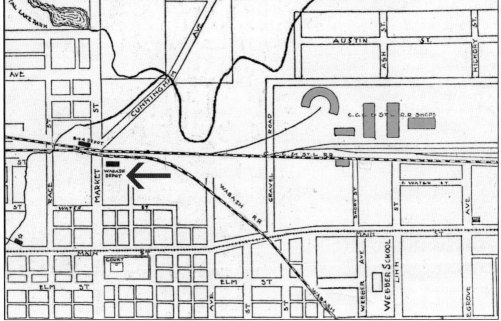

Railroad fever continued through the end of the 19th century. In 1880 and 1881, the state's first east–west railroad, the Great Western Railway (Wabash Railroad), which ran from Meridosa on the Illinois River to Danville across southern Champaign County, extended a spur from Sidney to Urbana. The spur ran diagonally across East Urbana to Main Street and then continued west to Champaign. The railroad also built a depot (above) near Broadway south of the rails. With the Big Four already here, the new line proved of little economic use and was abandoned in the 1890s. The above detail from a 1906 map of Urbana shows the Wabash Railroad and the Big Four, their depots, and the Big Four railroad yards. In 1899, the Big Four also built a new station near Broadway (below) to replace the Griggs House, which was demolished in 1889.

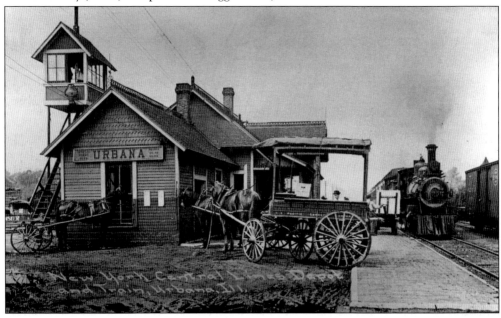

70

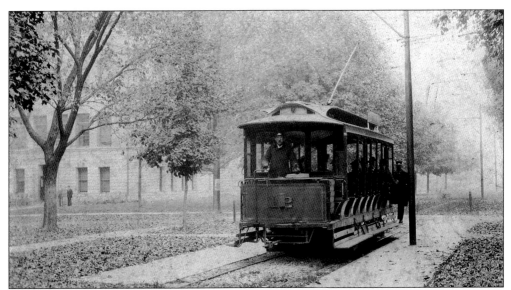

After nearly 30 years of service with mule power, the Champaign-Urbana street railway (above) was electrified in 1891 by William B. McKinley (below, inset), a Champaign banker and entrepreneur. The following year, he sold the line to Benjamin F. Harris Jr., the 25-year old-son of Champaign's land and cattle baron, who had expanded the line into a complex system of routes that included the university campus, the Champaign County Fairground, and Woodlawn Cemetery, and terminated in a new amusement park in west Champaign (the present Eisner Park). After acquiring and consolidating the local gas, electric, and water companies and the street railway into a single company, McKinley established the first electric interurban railway (below) to connect Urbana and Champaign to Danville. Started in November 1902, by the next decade, the line crossed the Mississippi River to St. Louis on the McKinley Bridge.

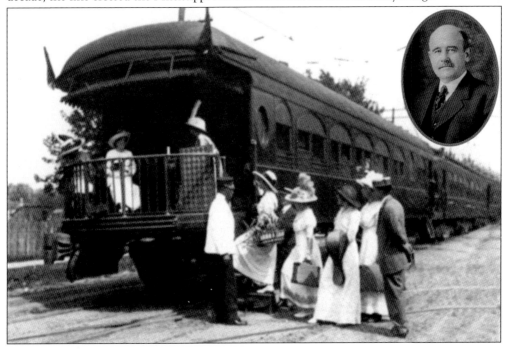

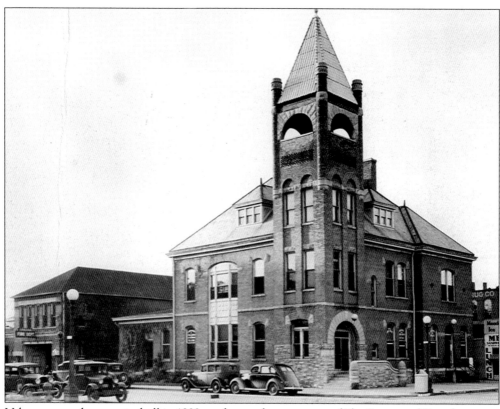

Urbana erected a new city hall in 1893 on the northwest corner of Elm Street and Broadway, east of the courthouse. The two-story brick building had a massive bell tower with the front entrance at its base. The tower was supplied with a bell in 1903, a donation from the Urbana firemen. The city's fire department, which up to this time was located at 107 North Broadway, was also moved into more spacious quarters. The two-story brick building constructed for it stood on Elm Street on the west side of city hall (above). The old picture below was taken of the department's horse-drawn carts standing in front of the new fire station. Horses were replaced by motorized vehicles in 1913.

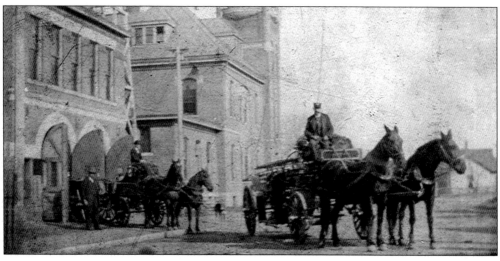

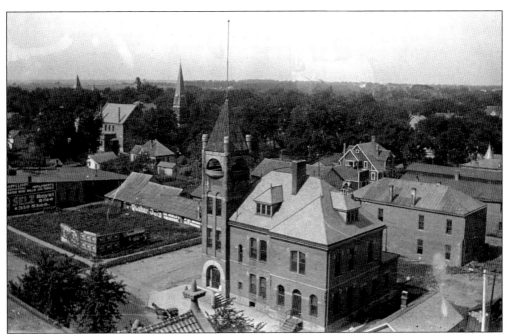

This interesting aerial view (above) of Urbana City Hall and fire station was taken around 1900 from the tower of the Champaign County Courthouse. In the distance is the spire of the Methodist church on Race and Green Streets. The Urbana Lincoln Hotel (1924) was not yet built. The photograph below was taken of the water wells of the Champaign-Urbana water works located in northwest Urbana along Church Street east of Goodwin Avenue. The twin cities installed a central water system early as a result of a lucky incident. Drilling for coal at this location in 1883, a group of Champaign businessmen struck a rich aquifer, which prevented further search. Not deterred, in February 1884, they incorporated and built the twin cities' first water works. Water mains were laid in Champaign in 1885 and in Urbana the following year.

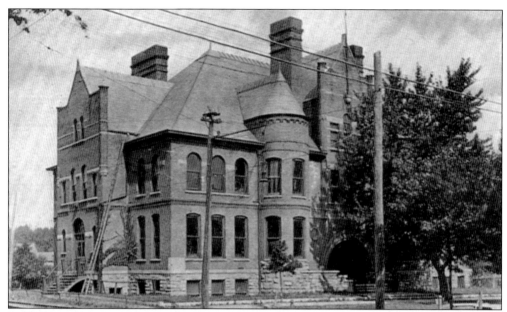

In the late 1800s, several new schools were established in Urbana. In 1896, a new high school was built on the northwest corner of Springfield Avenue and McCullough Street. The two-story brick building was designed by Rudolph Zerxes Gill, a University of Illinois graduate and son of pioneer Urbana carpenter and contractor Zachariah E. Gill. Land for the school was donated by Urbana resident John Thornburn after whom the school was named. The photograph below was taken in 1912 of a group of happy girls in togas who were members of the Thornburn High School Latin Club.

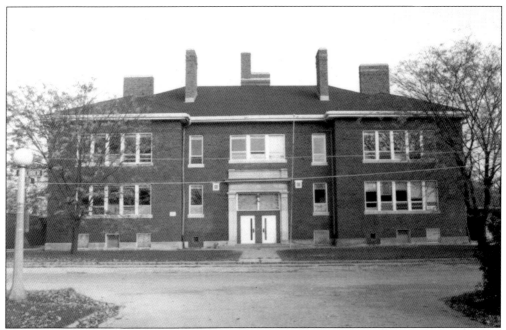

Webber School was built in about 1896 on land donated for this purpose by George G. Webber, a pioneer landowner and resident of East Urbana. Located at 112 South Webber Street at the east end of Elm Street, this two-story brick school was built to replace the earlier and much smaller East Ward School that was located at 305 South Urbana Street. The new school served not only East Urbana's growing population but also farm children living in outlying areas east of Urbana who were able to reach the school via the interurban that ran along Main Street. The school expanded several times over the years, but was closed in 1980 and sold to the Webber Street Christian Church, located across from it, which demolished it in the 1980s. The photograph below was taken of the school's third graders in 1907.

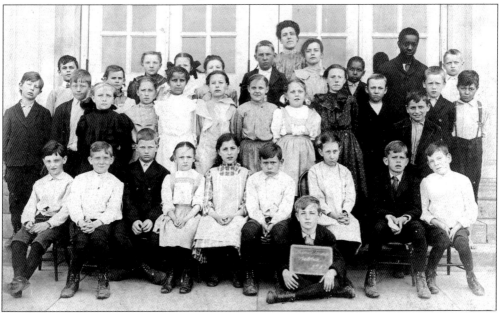

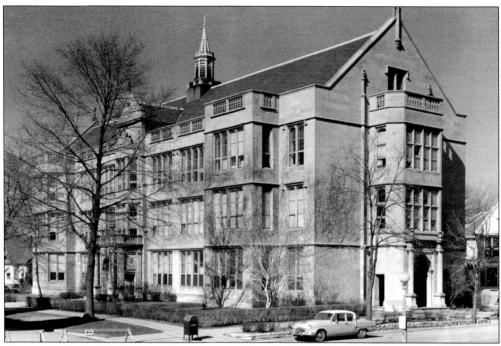

University High School, generally known as "Uni High," was built between 1916 and 1918 on the northeast corner of Springfield Avenue and Matthews Street. The building was designed by the well-known Chicago firm Holabird and Roche and opened for teaching in 1921. The school was built by the University of Illinois to replace the earlier academy that provided remedial education for students from rural areas who were not sufficiently prepared for university studies. The new high school filled the function of preparatory school as well as a teaching practice school for university students enrolled in the College of Education. The two-story brick building below is the second high school on the grounds of the present Leal School, erected after the first one burned down in the early 1870s.

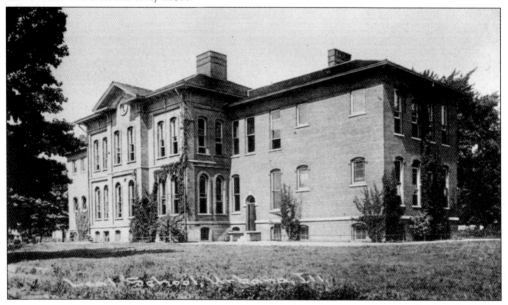

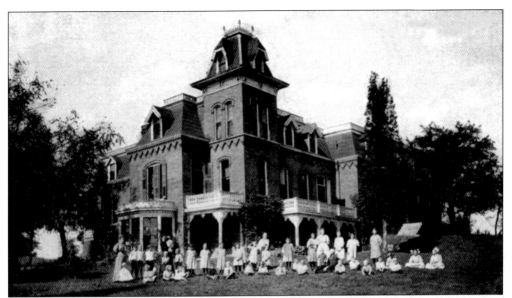

In 1894, Judge Joseph O. Cunningham and his wife, Mary, donated their home on Cunningham Avenue with the surrounding 15-acre estate (above) to the Women's Home Missionary Society of the Illinois Conference of the Methodist Church for use as an orphanage. The institute gave a home to hundreds of children over the years of its operation. At a later date, the Cunningham home was replaced with a more modern structure, which still functions as a school. The first kindergarten in Urbana was opened by Kate Baker Busey, wife of banker George M. Busey, in her home at 503 West Elm Street (below). She was a trained teacher and as a young woman taught wood sculpting at the Hampton Institute in Virginia, one of the nation's first black colleges. The home was torn down in 1989 and was replaced by a large apartment complex.

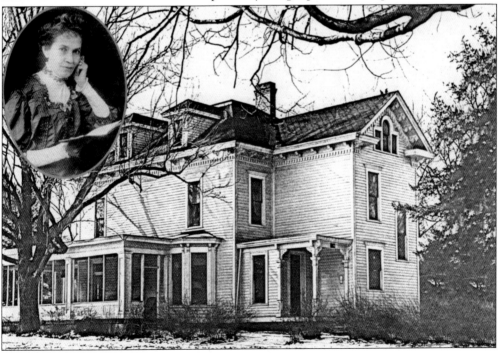

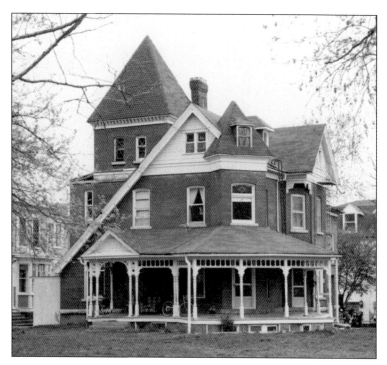

The last two decades of the 19th century were the era of Victorian buildings. A number of homes in Urbana were built in this style, concentrated on Main, Elm, and Green Streets. The residence of Elizabeth Sutton, Royal Sutton's widow, at 502 West Elm Street (seen here), is an example. Built in 1889, it is one of the rare brick residences in town, and it is reflective of the flamboyant lifestyle of the city's well-to-do.

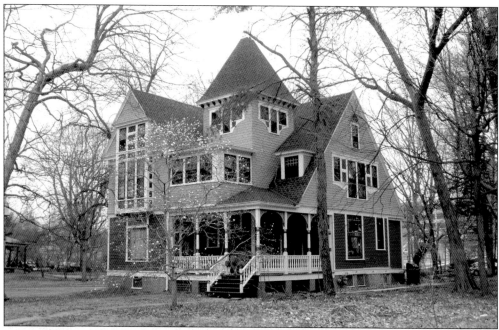

Another elegant Victorian residence was built in 1892 at 510 West Main Street (seen here) by Louis Wahl, a downtown saloon owner. Wahl was not only wealthy but also eccentric. He kept a six-foot alligator in a pond behind his house, whose escape and disappearance caused general consternation in the city until found five days later hiding in an abandoned well of the Sutton Brick Factory. (DR.)

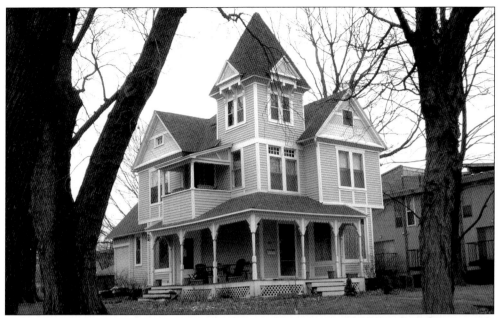

The intriguing Victorian house above was built in the 1890s at 605 West Main Street, a half block west of Wahl's house. Its owner was John H. Savage, a Connecticut native who came to Urbana in 1873. Savage was a banker, politician, and prominent public figure. For 10 years after his arrival to Urbana, he was deputy treasurer of the county. He was also a councilman and president of three organizations—the Citizens' Building Association of Urbana, the Urbana Banking Company, and the Urbana School Board. The Victorian residence below was built in 1892 at 506 West Main Street, two houses east of Wahl's house. The building was designed by Urbana architect Martin W. Kaucher for Frank M. Marriott, a wealthy Somer township farmer who retired to Urbana. (DR.)

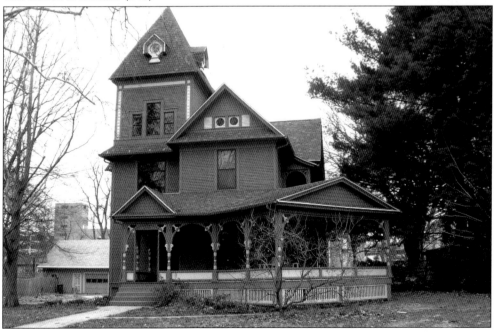

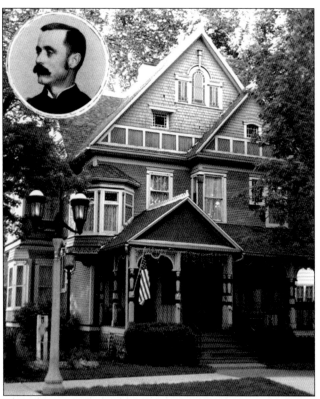

This elaborate Queen Anne–style home was built in 1895 by Urbana physician Austin M. Lindley and his wife, Minnie, at 312 West Green Street. The house stood next to that of Thomas S. Hubbard, Minnie's father, who gave the land to build upon. Prior to this construction, a smaller cottage stood at this location, which was the home of John M. Thornburn, donor of the land for the Urbana high school named after him. (IM.)

The relatively less-elaborate home in this photograph was built by Nathan C. Ricker, first head of the Department of Architecture at the University of Illinois. Ricker built this house for himself and his family at 612 West Green Street in 1892. This is the only residential structure in town known to have been designed by him. (DR.)

This edifice, with its unusually tall, spiraling tower, was the third sanctuary built by the Methodist Episcopal Church. The church was erected in 1892 at the southeast corner of Race and Green Streets, where its predecessor once stood. It served until 1926, when it was replaced by the present sanctuary.

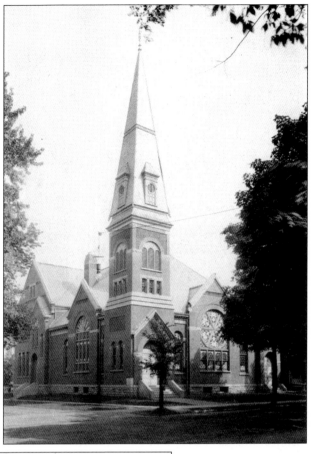

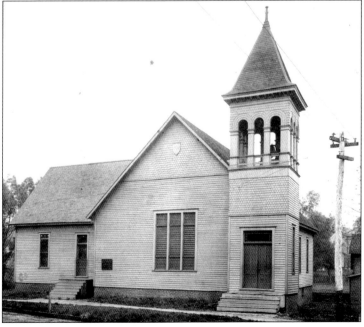

This small, frame sanctuary was constructed by the Christian church in 1889 at 401 West Main Street. The building served until 1910, when it was replaced by an elegant new sanctuary located directly across the street at 402 West Main Street. The latter church is now the home of Canaan Baptist Church. The original, small sanctuary was demolished.

Nathan C. Ricker entered the University of Illinois in 1870 as the first student of the Department of Architecture, which existed on paper only. The next summer, he obtained a thorough practical education in Chicago while rebuilding the city after the great fire. In the fall, he was asked to take over teaching, which he did and examined himself and three other students. Receiving his diploma on March 12, 1873, he became the nation's first graduate in architecture. That fall, he was appointed head of the department, and he remained a lifelong faculty member, teaching, writing, and designing buildings for the university. The three structures flanking the Illini Union—Harker Hall, Altgeld Hall, and the Natural History building—are all his designs. The early photograph below was taken of the elaborately decorated rotunda of Altgeld Hall.

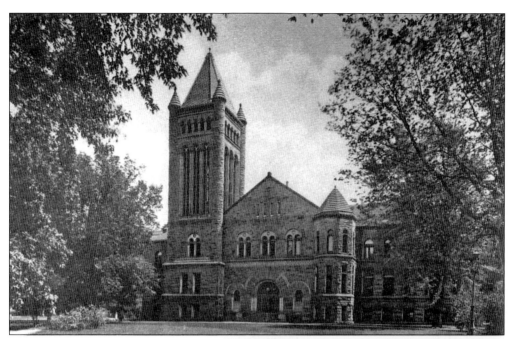

The university's first library building (now known as Altgeld Hall) was designed by Ricker and his former student and colleague James McLaren White. Built of pink sandstone with a red clay tile roof in Richardsonian Romanesque style, the building was dedicated in 1897. Later it was renamed Altgeld Hall after John Peter Algeld, the first democratic governor of Illinois (1893–1897), who was a self-educated man and ardent supporter of public education, and played a key role in the library's construction. The library's first director and head librarian was Katharine L. Sharp, a graduate of the New York State Library School and "the best woman librarian in America" according to her professor Melvil Dewey. The photograph at right was taken of a group of students at the dawn of the 20th century pausing in front of the library's monumental entrance door.

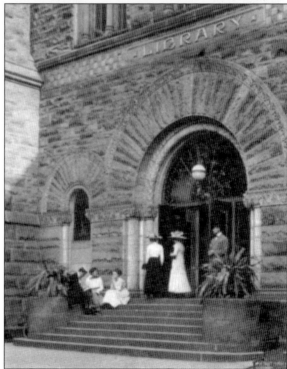

The first home built by the university for its president was located at the northeast corner of Green and Wright Streets across from Altgeld Hall. Its first resident was Andrew Sloan Draper, who served as university president from 1894 to 1904. The home's back yard was crossed by the Boneyard Creek which President Draper unsuccessfully attempted to rename "Silver Creek" to create a more dignified image for the city and university. The pleasant view of the university in the c. 1900 photograph below, with the elaborately designed towers of University Hall and Altgeld Hall and surrounding lush vegetation, recalls classic European cities, and is a far cry from the bleak campus that greeted the university's first students in the 1860s.

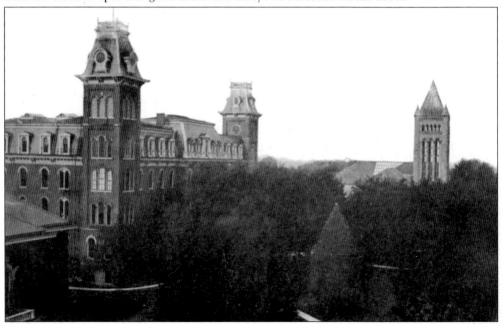

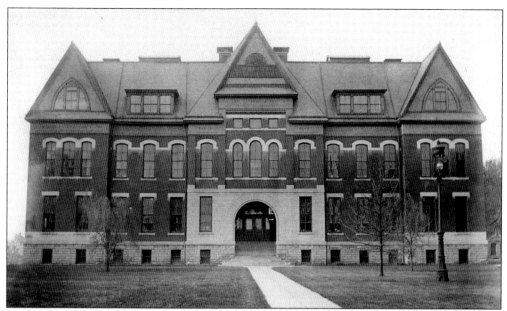

The Natural History building (above) was another edifice designed by university professor Nathan C. Ricker. Located on the southwest corner of Green and Matthews Streets, the building was dedicated in 1893. One of the first collections housed in the building was the herbarium, which was started by Thomas J. Burrill on his trip to the West in 1867 with John Powell, which was Powell's first exploratory trip in preparation of his Grand Canyon discovery expeditions. The agriculture building, presently known as Davenport Hall (below), was built in an effort by Eugene Davenport, dean of agriculture from 1895 to 1905, to rejuvenate the College of Agriculture. Due to his efforts, the college did become the state's leading agricultural center by the early 20th century. Dedicated in 1901, the building stands on the east side of the university quadrangle at the termination of Oregon Street.

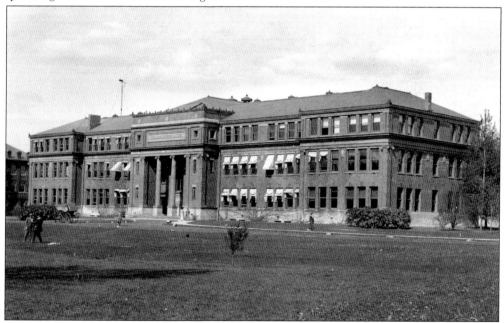

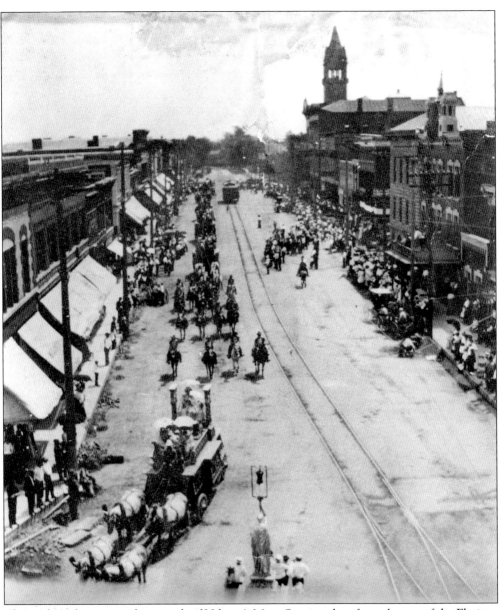

This early-20th-century photograph of Urbana's Main Street, taken from the top of the Flatiron building, is an impressive testimony to how far the city has come from its humble beginnings. The city's spirit and energy are aptly symbolized by the spiraling tower of the new Champaign County Courthouse and the Flatiron building, modeled after New York City's Flatiron, the world's tallest building at the time.

Five

THIS CITY IS BUZZING
1900–1930

The early 20th century was a time of improvements and construction in Urbana through which the city had in effect recreated itself. Much of the older housing stock, businesses, and public buildings were replaced, and the city's size nearly doubled. Symbolic of this energy and high aspirations were the new county courthouse, with its high, spiraling tower, and the Flatiron building, Urbana's largest business building to date, which was modeled after the Flatiron building in New York, then the world's tallest building. Both were designed by architect Joseph W. Royer, a 27-year-old Urbana native and University of Illinois graduate (1895). His designs were so successful that he was subsequently hired to redesign nearly all of downtown Urbana, including a theater, a post office, a library, a jail and sheriff's residence, a large hotel, three churches, and several business buildings and private homes.

In the early 20th century, culture and entertainment came to the fore. The old vaudeville opera halls were replaced by a large, four story, self-standing theater; movie houses opened; and the public library got its first building. A number of public parks were established, where one could go boating or strolling and enjoy lectures, plays, and music. After the establishment of Carle Park on Urbana's southern outskirts, the city began to expand southward, with the first residences being built around the park. The prairie between Lincoln Avenue and the university campus also began to be filled in with elegantly built homes. During this period, many local churches built new sanctuaries, all elegantly designed in brick and stone. Two local hospitals began to serve the city's increased demand for health care. A large number of projects were financed from private donations or by consortiums of local businessmen, demonstrating the citizens' commitment to, and pride in, their city.

Under the presidencies of Edmund Janes James (1904–1920) and David Kinley (1920–1930), the university experienced unprecedented growth and prosperity. Besides the regular educational buildings, a theater, a large football stadium, a hospital, elegant dormitories, monumental art works, and beautiful landscaping were established. In 1921, enrollment passed 10,000, and the University of Illinois was the third largest university in the nation.

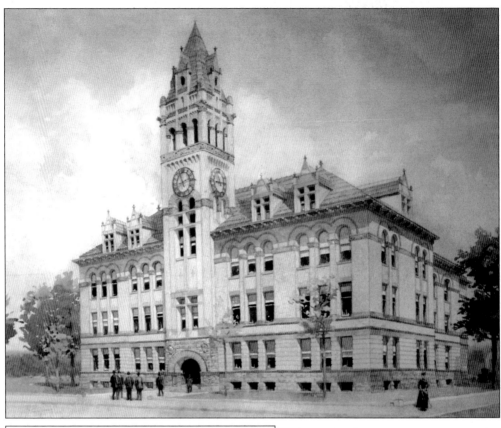

J. W. Royer.

The new millennium was inaugurated with a new courthouse. Construction of the fifth Champaign County Courthouse began on May 1, 1900, and it was dedicated on August 25, 1901. Plans were prepared by Joseph W. Royer. The courthouse was built of red mottled bricks and red sandstone with a tile roof and a clock tower facing Main Street. The interior had marble floors, wainscoting, and elaborate frescoes. Joseph W. Royer, Urbana's native, premier architect, was born in 1873. He graduated from the University of Illinois in 1895 and served as Urbana's city engineer between 1898 and 1906. Subsequently he established his own architectural firm, which was located in the Flatiron building on Urbana's Main Street. The architectural character of downtown Urbana is defined by his designs, as he prepared plans for nearly all of the city's major public and business buildings.

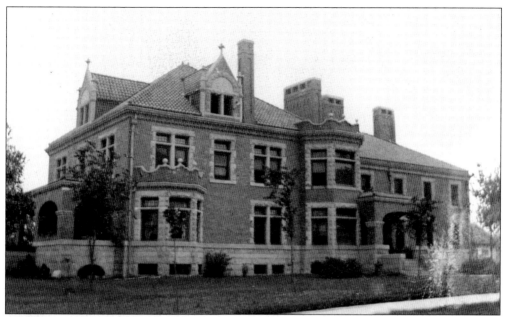

The design of the new Champaign County Courthouse established Royer's reputation. In 1905, he was hired to design a new jail and sheriff's residence to be situated directly to the east of the courthouse on the site of the previous jail. The two-story, chateauesque-style structure was built of red bricks with a tile roof to match the courthouse. The substantial and elegantly designed new courthouse and jail/sheriff's residence, seen in the early 20th century photograph below, changed the former small-town feel of the public square to an attractive, urbane appearance. The jail/sheriff's residence complex was demolished in 2000 for the expansion of the courthouse.

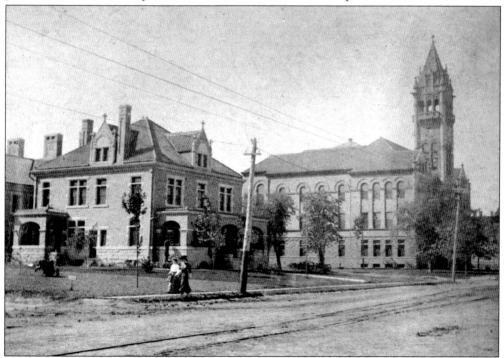

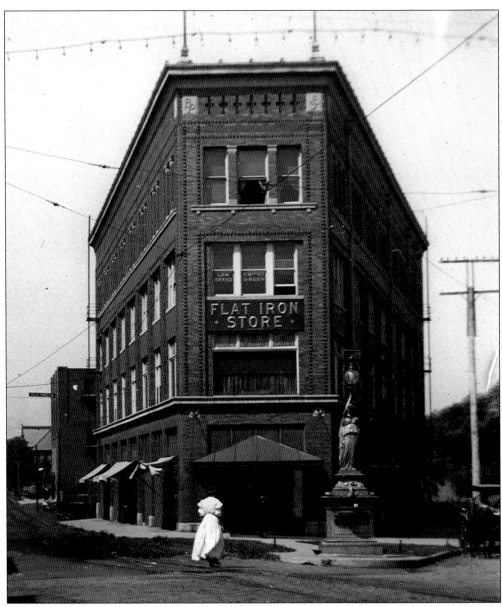

The Urbana Flatiron building was constructed in 1906 at the intersection of Main Street and Springfield Avenue. The four-story brick edifice, the city's most ambitious business building to date, was designed by Joseph W. Royer to be a thoroughly modern structure. It was modeled after the Flatiron building of New York City, a 21-story skyscraper designed by Chicago architect Daniel Burnham, which was at the time (1902) the world's tallest building. The building site was staked out on March 1, 1906, by Royer himself, and the first occupants were moving into the building by August. The building originally housed the Flatiron Department Store in the basement and on the first two floors, Royer's architecture offices and law offices on the third floor, and the Elk's lodge on the top floor. Between 1907 and 1921, a metal statue of Frances Willard, founder of the Women's Christian Temperance Union, stood in front of the building, dispensing water into a basin. The building burned down in 1948, destroying Royer's lifetime work of architectural plans. The statue was turned into scrap metal during World War II.

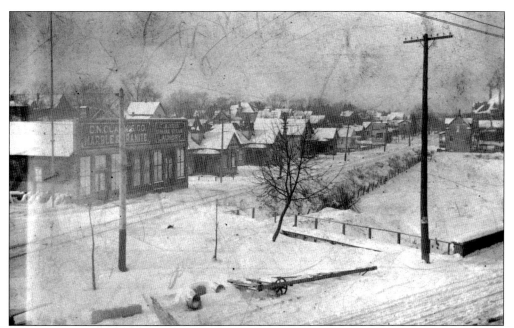

The photograph above shows the site of the Flatiron building at the junction of Main Street and Springfield Avenue. According to early accounts, this swampy area surrounded by a low fence had once been a buffalo wallow. Construction required the rerouting of the Boneyard Creek and the filling in of the swamp surrounding it. As seen in the view below, Royer's design fully transformed the property. The new Flatiron building became the dominant feature of the west end of Urbana's business district, serving as a visual anchor in town. Fine, new homes were being built along West Main Street, a tree-lined avenue. The Knights of Pythias building, with a Royer-designed facade (1903), was directly opposite and can be seen on the right side of the view below. Lou McWilliams's widely popular hats were sold on the building's ground floor.

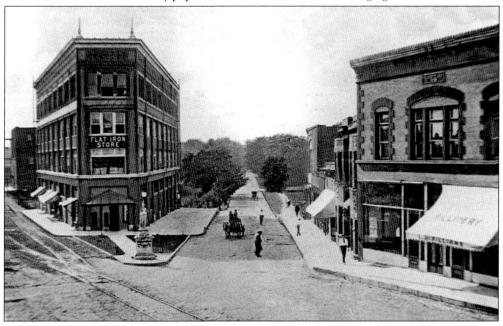

The Stephens building at 218 West Main Street was erected in 1903 next to the Knights of Pythias. The two-story redbrick building housed Boyd C. Stephens's photography studio on the ground level and apartments on top. It is assumed that this building was also designed by Joseph W. Royer based on its style and on the fact that he established his office and residence there immediately after its completion. The Cohen building at 136 West Main Street (below) was built in 1907 by Nathanial Cohen, a popular Urbana opera singer. Designed by Royer, this two-story brick building housed Cohen's cigar factory on the second floor and a barbershop and the Urbana Banking Company on the ground floor. The photograph also shows Urbana's early post office, designed by Royer in 1906, located directly behind the Cohen building. (Above, DR.)

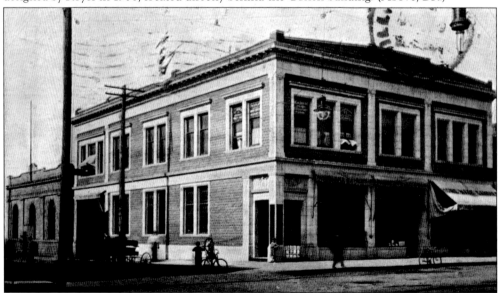

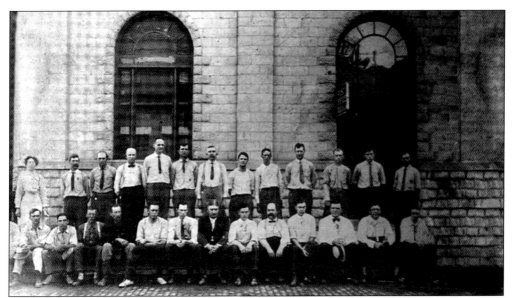

The city's modernization continued with the construction of a new post office in 1906. It replaced the former Urbana Courier building at 106 North Race Street, and its foundations were laid with bricks from the Courier. Designed by Royer, the post office was built of concrete blocks, a new building material manufactured in Frank A. Somers's factory a few yards north of the post office along the Boneyard Creek. In 1914, the post office was moved to its present location, and in recent decades, the old post office was sided with artificial bricks and currently functions as the Rose Bowl Tavern. The *Urbana Courier*, the city's premier daily newspaper since 1894, moved to a new building (below) across the street from the old post office. The newspaper folded in 1979, and in 1980, the present Courier Café moved into the building.

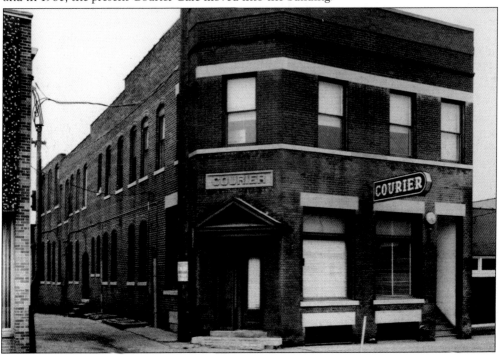

The old Tiernan building at 115 West Main Street, built by Frank Tiernan in 1871, was purchased by the Masons in 1889. The organization converted the third floor to a lodge and the second floor to a banquet hall. In 1914, they hired Joseph W. Royer to redesign the building's facade. His elegant, white glazed terra-cotta facade (left) is still visible on the front of the building. In 1926, the original Knowlton and Bennett Drug Store at 137 West Main Street was also replaced by a new building designed by Royer. Seen in the photograph below, the new structure was faced with wire-cut buff bricks (later painted brown) and panels of white ornamental terra-cotta, featuring decorative polychrome shields. Closing in the 1970s, the drugstore operated at this corner for about 100 years. (Left, IM.)

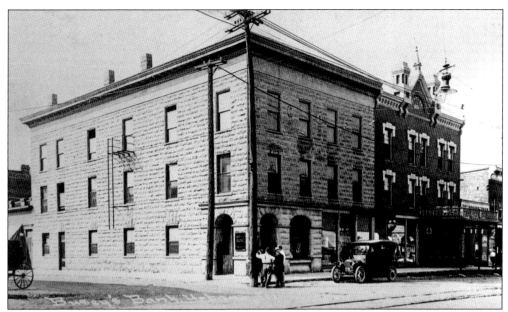

Busey Bank (above) started the new millennium in a new location. In 1904, after extensive exterior and interior remodeling, the bank moved to the ground floor of the three-story double building on the southwest corner of Main and Race Streets (the original Urbana Brick block), which had formerly housed Morris Lowenstern's clothing and dry goods store. The building immediately to the west was the Columbian Hotel, built in 1888 by Lowenstern. In 1907 and 1908, Urbana's early vaudeville opera houses, Busey's and Tiernan's Halls, were replaced by the four-story Illinois Theater, designed by Royer (below). It was erected just west of the Flatiron building at 312 West Springfield Avenue. Nationally known artists, including Enrico Caruso, Sarah Bernhardt, Jenny Lind, and Al Jolson, preformed under its proscenium. The theater burned down on April 3, 1927.

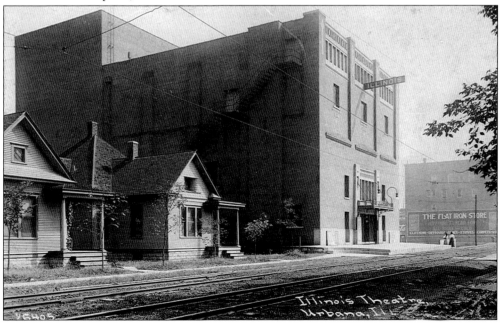

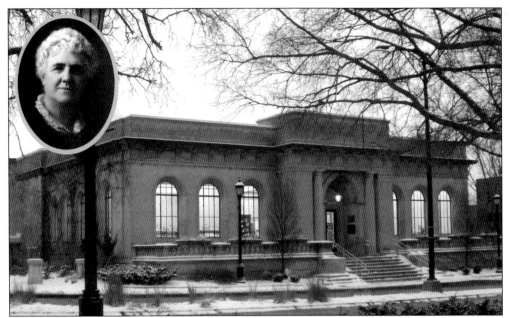

An important addition to Urbana's cultural life in the early 20th century was the public library, built in 1917 and 1918 at the intersection of Elm and Race Streets. After 44 years of operating in small rooms in various downtown buildings, Mary Busey, widow of Samuel T. Busey, made a donation of $35,000 to build the library as a memorial to her late husband. Joseph W. Royer was hired to draw up plans. (DR.)

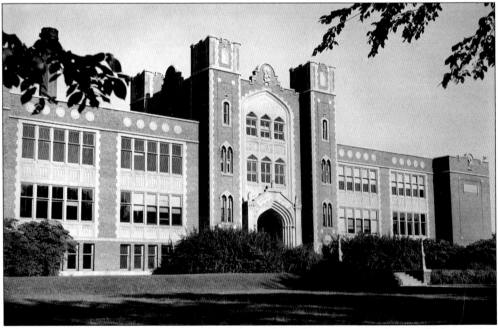

Another important cultural facility built in the early 20th century was the new Urbana High School. Designed by Royer, the high school was constructed in 1916 at the intersection of Race and Iowa Streets across from Carle Park. The massive three-story building was constructed of redbrick with limestone decorative elements and ornamentation at a cost of $150,000.

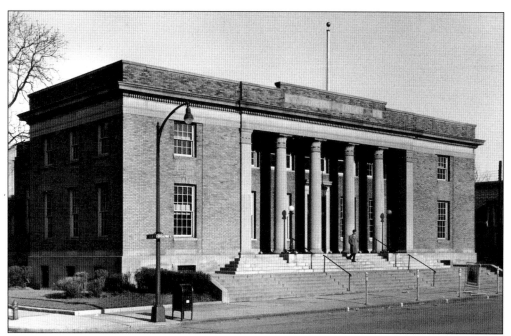

In 1914, the privately owned post office, constructed on Race Street behind the Cohen building, was replaced by a much larger one courtesy of the federal government. Built of tan brick with a grand entrance flanked by four massive columns, it was sited on the southeast corner of Elm Street and Broadway across from the courthouse. The supervising architect was Oscar Wenderoth.

Another early-20th-century federal project was the construction of the World War I armory building at 308 West Main Street. The two-story redbrick structure was erected in 1915 to house the state's horse cavalry. Deactivated after the war, the building was used as an automobile repair shop, and eventually it became a storage facility. In December 2008, the building was demolished. (DR.)

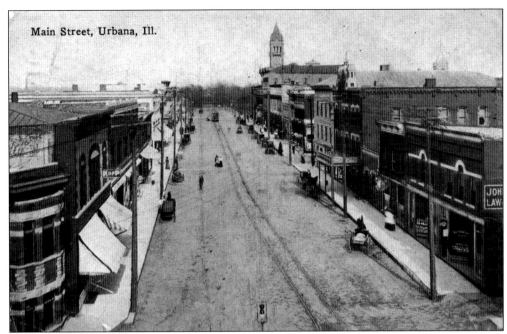

Main Street, Urbana, Ill.

This impressive vista of Urbana's Main Street was captured in the second decade of the 20th century from the top of the Flatiron building, which held a prominent position at the west end of downtown. Looking east, the picture reveals Urbana's main business district with the courthouse tower in the distance and the bay windows of the Stephens building in the front left corner. The streetcar rails running east in the middle of the road intermix with horse and buggies and early automobiles. The view below was taken from the front of the courthouse looking west. The Flatiron building is seen in the distance at the end of the street, while the Cantner business block on the northwest corner of Broadway and Main Street dominates the front right.

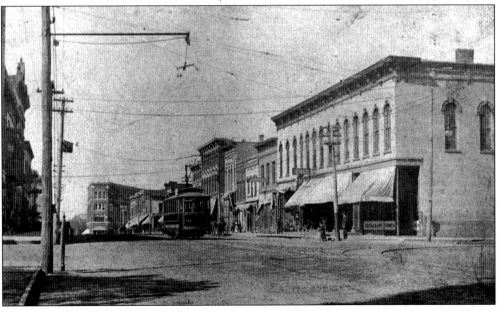

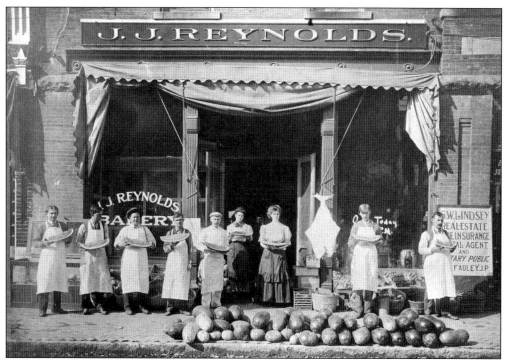

In addition to Main Street, the downtown portions of Race and Elm Streets were also important business blocks. The watermelons offered so enticingly in this picture come from the store of J. J. Reynolds, whose business at 117 South Race Street offered fresh produce and shelves of canned goods stacked from floor to ceiling. The store also included a bakery. The picture below was taken from the middle of Race Street in front of the public library looking north toward Main Street. On the left is the Oldham Brothers' Drug Store located on the northwest corner of Race and Elm Streets followed by Reynold's store in mid-block. In the distance at the end of the block is Busey Bank, anchoring the southwest corner of Race and Main Streets.

One of Urbana's most ambitious construction projects in the early 20th century was the Urbana Lincoln Hotel, a five-story structure built in 1924 on the southeast corner of Race and Elm Streets. Designed by Joseph W. Royer in Tudor Revival style, the hotel was constructed of brick with wood battens and a slate roof. The elegant hotel and restaurant complex offered the best quality service to visitors of Urbana. The picture above was taken of the hotel while it was under construction, looking north towards the city hall. The hotel's construction was initiated and financed by a consortium of 100 Urbana businessmen and investors who appear in the group photograph below.

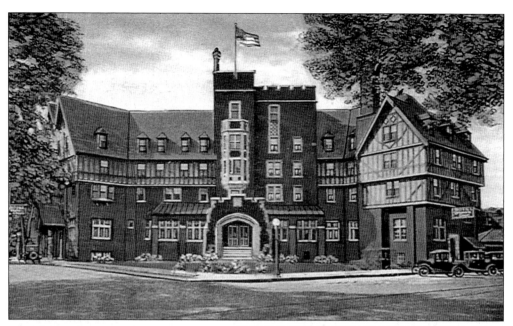

The Urbana Lincoln Hotel was built near the old Kerr Hotel, where Abraham Lincoln stayed on many occasions while serving on the Eighth Judicial Circuit. The hotel's name, determined by popular vote, commemorates his connection with Urbana and this particular location. The entrance, which faces toward Green Street (above), has been obscured by a mall that was built around it in 1963 and 1964. In 1927, a bronze statue of Lincoln, made by Lorado Taft, a former resident and University of Illinois graduate, was placed in front of the hotel. The statue was created from a bequest given to the city for this purpose by Urbana benefactors Joseph O. and Mary Cunningham. The statue remained in front of the hotel only for a few months where the rare photograph at right was taken, and then it was moved to Carle Park where it remains today.

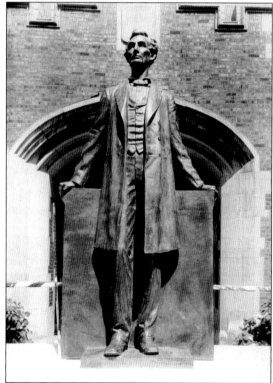

This view from the intersection of Green and Race Streets, looking north toward Main Street, shows a row of the majestic American elm trees that had offered a shady canopy over many city streets long before Urbana became one of the original charter members of "Tree City USA." The numerous residential houses that existed at that time just south of Main Street were convenient to downtown businesses and shopping.

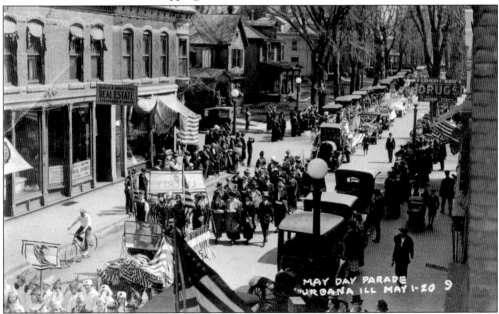

This May Day parade scene, dated May 1, 1920, shows a continuous line of organizations walking north on Race Street. A tableau of youths dressed as Uncle Sam and Liberty stand in the front vehicle. The photograph was probably taken from a second-story window in the Busey Bank building on Main Street looking south. On the left side is the northeast corner of Elm and Race Streets.

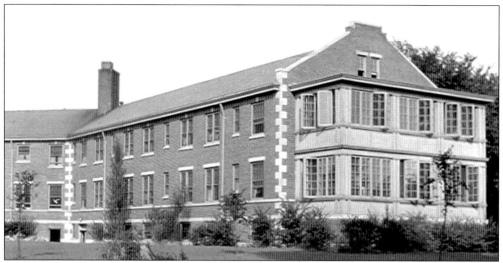

In the 1920s, Urbana established its first health care centers. Carle Foundation Hospital was created from the Urbana Memorial Hospital Association, which was founded with a $40,000 bequest from Margaret Carle Morrison, widow of Albert G. Carle, in 1917. Its original facilities were located in the former Simeon H. and Artemisia Busey home on University Avenue, which was donated for this purpose by their children in 1920. The view above shows the so-called Y building, the first hospital facility added to the Busey home between 1925 and 1927. Mercy Hospital, the forerunner of the present Provena Medical Center, is shown below as it appeared in the 1920s. Located at the northeast corner of Park and Wright Streets, it opened under the management of the Sisters of Mercy from Switzerland. Both hospitals have undergone several additions, and their original buildings have been demolished.

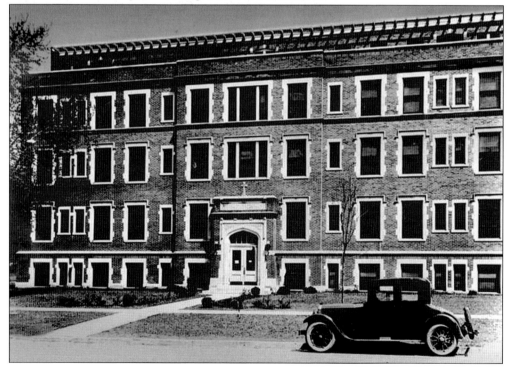

Crystal Lake Park started as a privately owned park called Union Park, just north of Urbana. Between 1881 and 1887, businessman Jacob Y. Wallick purchased about 40 acres of woodland along the Saline Branch and dammed up the creek at Broadway to create a lake in the low-lying areas. By 1886, one could take a rowboat or small steamer around the lake or upriver and picnic in the park on the high ground. Crystal Lake Park was changed to a public park in 1907 under the aegis of the Urbana Park District. The lake was dredged in 1910, and from the dredge, Cannonball Hill, a favorite sledding place, was built. The lake house, built about 1900, was also renovated and was eventually replaced in 1986. The park has expanded and changed over the years, and boating and fishing remain favorite summer activities.

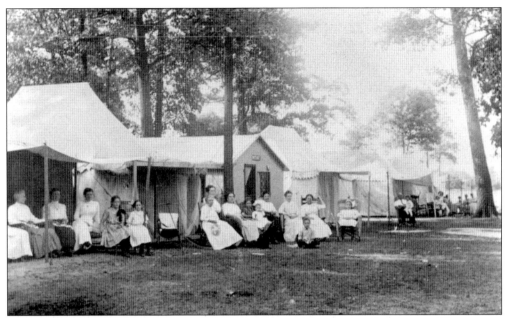

A favorite activity in Crystal Lake Park in its early days was the summer chautauqua. Chautauquas started at Lake Chautauqua in New York in 1874 as popular outdoor education events. Beginning in 1896, Crystal Lake Park was also home to these activities, as families moved into summer encampments to escape the heat and enjoy the chautauqua lecture series and concerts held in the park. The scene above dates from 1910. In 1909, a new park was established just south of Urbana. That year, Margaret Carle Morris donated 8.3 acres of her large estate and $10,000 for the creation of Carle Park, as a memorial to her first husband. Landscaping was designed by J. C. Blair, who also laid out Victory Park in East Urbana. The pavilion (below) and adjacent fountain were also built from her bequest.

In addition to public and business buildings, Joseph W. Royer, Urbana's premier architect, also designed private homes. His first known private residence is located at 210 South Grove in Urbana, which he designed for Mary Lloyd, daughter of pioneer Urbana businessman Alexander Spence. This was followed by dozens of other homes, including his own (above), which was built at 701 West Busey Street in 1905. This mission-style home remained his lifelong residence. In 1923, he also designed a small cottage at 803 South Busey Street (below) for his mother-in-law, Ella Daneley, next to his own home. This house was featured in the *Fairy Book* (below, inset), a children's storybook published in 1925, written by Royer's wife, Adelaide, and illustrated by Adelaide's sister Nell Brooker Mayhew, a nationally known painter. (DR.)

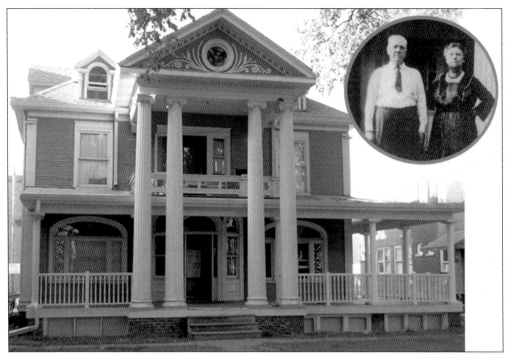

In 1902, Royer was hired to design a new home for Gus and Alice Freeman. Built in 1902 and 1903, this stately classical revival–style home with two-story Corinthian front columns stands at 504 West Elm Street (above). Gus Freeman was the owner and operator of Urbana's first permanent movie theater, the Princess, which opened in 1915. It was located on the first floor of the old Busey block on Main Street, which was half-owned by Simeon H. Busey, his father-in-law. Today the building houses the Cinema Gallery. Louise McWilliams, a well-known women's hat designer, maker, and store owner in Urbana, also hired Royer to design her home. Located at 607 West Elm Street, her classical revival–style home (below) was built in 1901 on a lot she purchased from Prof. Nathan C. Ricker. (Above, IM; below, DR.)

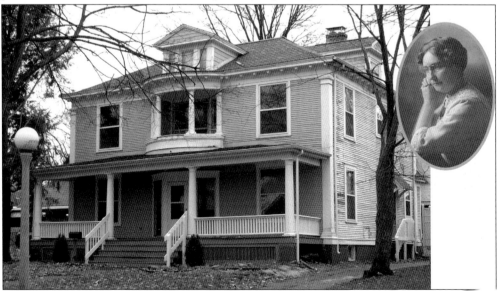

As the community grew in prosperity, new houses of worship arose, replacing less-imposing structures of earlier times. Shown on the left are three churches designed by local architect Joseph W. Royer. From the top are the second sanctuary of the First Presbyterian Church of Urbana at 602 West Green Street, built in 1901 and 1902 and replaced by a modern sanctuary in 1963 and 1964; the second sanctuary of the Christian Church (later known as the First Congregational Church), built in 1909 and 1910 at 402 West Main Street and now owned by Canaan Baptist Church; and the second sanctuary of the Unitarian Universalist Church, built in 1913 and 1914 at 309 West Green Street. The churches on the right side from top are the fourth sanctuary of the Methodist Episcopal Church, built in 1926 at 304 South Race Street; the first sanctuary of the Weber Street Christian Church, built in 1917 at 107 South Webber Street and replaced by a modern sanctuary in 1957; and the second sanctuary of the First Baptist Church of Urbana, built in 1896 at 202 West Illinois Street.

In 1901, the city's Catholic population erected St. Patrick Catholic Church at 708 West Main Street. This elegant redbrick building with white limestone decorative elements was designed by George P. Standuhar from Rock Island. The church remains the largest sanctuary of Urbana's Catholic population.

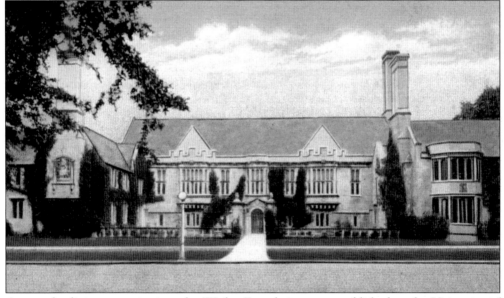

A special religious organization, the Wesley Foundation was established at the University of Illinois campus in 1913, organized by the local Methodist church. It was the first religious organization nationally, created to serve the spiritual and social needs of students at a state university campus. The foundation's building complex was built over 38 years, and the so-called social center building (seen here) was the first in 1920 and 1921. Located on the southwest corner of Green and Goodwin Streets, the building was designed by the noted Chicago firm Holabird and Roche in transitional late Gothic, early Renaissance style, modeled after John Wesley's alma mater, St. John's College in Oxford.

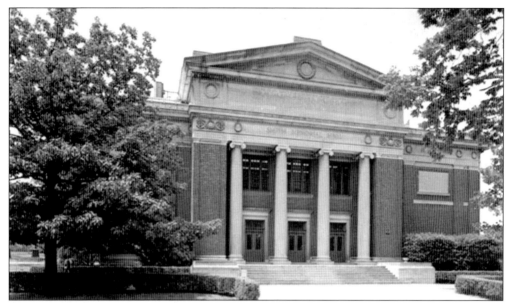

Smith Music Hall, built in 1920 directly east of Follinger Hall, was the first building on campus constructed without state funds. The building was constructed from money donated by university trustee and attorney Thomas J. Smith as a memorial to his wife, Tina. The building's interior was elaborately decorated with panels of painting. Foellinger Auditorium, prominently located at the south end of the university quadrangle (below), was dedicated in 1907 to serve as the university's music hall, lecture room, and auditorium. John Philip Sousa (below, inset), a personal friend of the school's regimental band director A. Austin Harding, visited the campus several times between 1908 and 1930 and conducted a series of concerts to great acclaim. Sousa donated nearly all of his musical scores to the university before his death, making the university the nation's largest depository of his musical heritage.

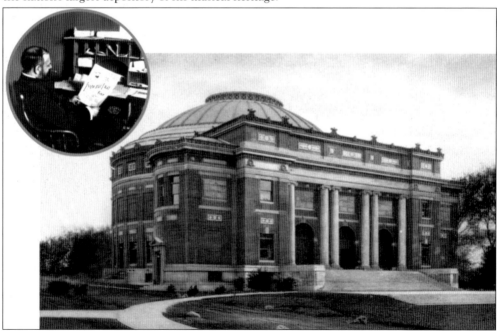

Nationally acclaimed sculptor Lorado Taft, a former resident and University of Illinois graduate in art (1879), contributed several of his works for the university's beautification. Most famous of these is his *Alma Mater*. In the photograph, 69-year-old Taft is standing on the right in front of the *Alma Mater* with university president David Kinley, apparently at the statue's dedication in 1929 in its original location in the back of Foellinger Hall. The sculpture was moved to its present location near Altgeld Hall in 1962.

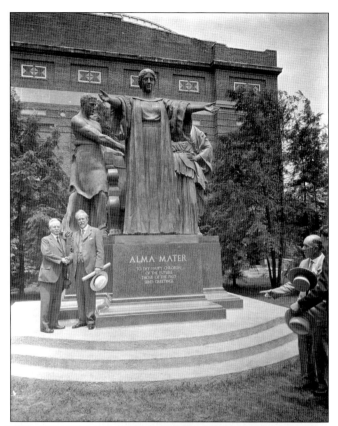

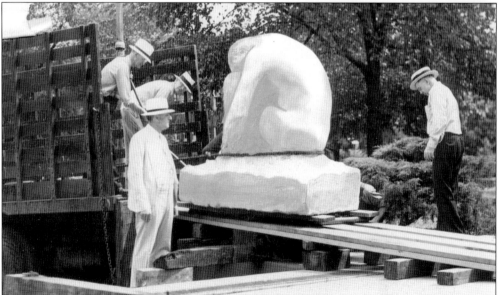

This picture was taken at the time Taft's sculptures the *Sons and Daughters of Deucalion and Pyrrha* were delivered to the university in 1933. Originally intended for the Fountain of Creation in Jackson Park in Chicago, which never materialized, the "sons" (seen here) are now located behind Feollinger Hall, and the "daughters" are on the staircase of the university's main library.

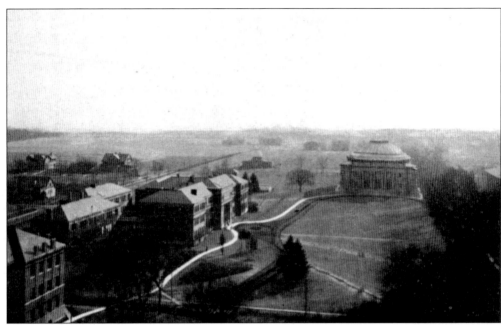

This aerial view of the university campus from 1914 shows the quadrangle as it began to take shape in the early 20th century as significant buildings were constructed around it. The picture was taken from the tower of University Hall looking south. In the distance is the Foellinger Auditorium, and on the left is Davenport Hall, the university's agricultural building. Burrill Avenue, a campus walkway shaded by majestic elm trees planted by Prof. Thomas J. Burrill and his students, runs along the right side of the quad. The aerial view below was taken of the university's Memorial Stadium, dedicated in 1924 as a memorial to university students who died in World War I. The stadium was designed by noted Chicago architects Holabird and Roche, who also designed the social building of the campus Wesley Foundation and University High School.

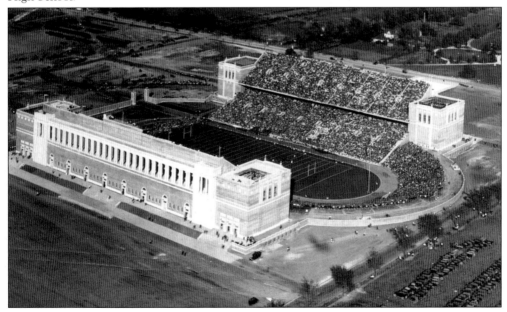

As the 20th century marched on, the university kept adding even more elegant buildings to its campus. The classically designed, three-story brick building above, located directly east of Smith Memorial Hall, was built in the 1920s as a women's dormitory to accommodate the growing number of female students enrolling at the university. The historic University Hall, demolished in 1938, was replaced by the Illinois Union building (below) in 1941. Its Georgian-style architecture was inspired by Colonial Williamsburg, Virginia. Its 30-foot bell tower contains the university's historic chapel bell and the clock from the old University Hall, a gift from the class of 1878. The building's south wing was added in 1961. The Illinois Union building offers beautiful paneled lounges, meeting rooms, and a number of guest room accommodations for visitors.

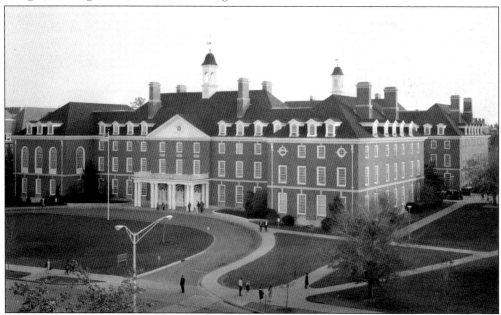

With continuous attention and care, the formerly barren university grounds acquired a beautiful parklike appearance by the early 20th century. The Boneyard Creek wound its way east behind the university president's new residence, where it was enhanced with a small, rustic bridge and hot houses along its banks. The introduction of beautiful varieties of trees and flowering plants as part of the learning curriculum was one of the benefits of being an agricultural university. Thomas J. Burrill, professor of botany and horticulture, personally planted hundreds of trees on the campus, slowly turning it into a lovely park. The beautiful walkway across the campus quadrangle that was lined with magnificent elm trees planted by Burrill and his students was named Burrill Avenue in his honor. The photograph below shows the north end of Burrill Avenue before its devastation by Dutch elm disease.

Access between the campus and the surrounding community was convenient, all areas being connected by a system of electric streetcars. Students could wait for the local streetcars and the interurban train at different points on campus. This Victorian streetcar stop once stood on Green Street in front of University Hall. Now it serves as a bus stop located by the Natural History building on Matthews Street. If transportation was unavailable on a Sunday afternoon, students could walk down to the pastoral lily pond located in the southeast part of campus. Established in 1916, the pond was filled in 1961.

The road to modernization lead through the large-scale destruction of older, still-functioning buildings that were declared unsuitable for contemporary use. In downtown Urbana, entire city blocks were demolished and replaced by modern buildings. In this 1979 picture, a backhoe operator is removing rubble from a pavement cave-in west of the courthouse, while north of it, the new Champaign County Bank and Trust building rises behind the old First National Bank.

Six

THE ROAD TO MODERNIZATION
1930–2009

The 1930s and 1940s were a time of trouble and hardship affected by forces beyond the city's control—the Great Depression and World War II. The city weathered the depression as its mayor ordered the printing of Urbana money to back the transactions of citizens until local banks were stabilized. After World War II, massive numbers of servicemen returning home flooded the university, looking for education and homes. To meet these needs, many of Urbana's beautiful, stately homes in the city's historic area on Main, Elm, Green, and High Streets were converted to apartments and began their slide toward neglect and oblivion. The end of this era was marked by the loss of the two prime symbols of Urbana's former aspirations and prosperity. On March 11, 1948, the city's largest business building, the Flatiron, burned to the ground in a dramatic conflagration, and after being struck by lightening several times, 14 feet of the top of the courthouse tower was removed in 1953, stunting the tower for the next five decades.

In the 1950s and 1960s, the appearance of many downtown buildings was changed by the imposition of modern facades. Entire city blocks were razed, including the old city hall, to make way for new office buildings and parking lots. Lincoln Square Mall, the first downstate enclosed shopping mall, was constructed in the heart of the city. The Champaign-Urbana streetcar lines closed in 1936, and the Big Four railroad yards were torn down in the 1950s, reflecting the nation's move to the automobile. The building of interstate highways drew residential construction and shopping to the outskirts, and the city's once thriving downtown lost its vitality. While downtown Urbana declined, the University of Illinois continued to grow and became the city's largest employer. Today it is a national leader in advanced computer science and technology and home to a large international student body. The current reconstruction of the courthouse tower to Joseph W. Royer's original design in downtown Urbana is a manifestation of trust in the city's renewed vitality as it celebrates its 175th birthday.

After the boom of the 1920s and Prohibition came the bust of the 1930s and the Great Depression, accompanied by poverty and crime. In this picture, Urbana police officers and Sheriff Fred Shoaf pose with $600 worth of illegal whisky that was confiscated during a police raid in a deserted printing shop at 108 North Walnut Street. The photograph appeared in the local newspaper on July 19, 1930.

The back side of Urbana money, printed in red so as not to confuse it with the dollars printed by Uncle Sam, is shown here. Mayor Reginald Harmon and the Finance Emergency Committee issued Urbana money in March 1933 to enable citizens to transact business while the banks were closed for reorganization. This currency was backed by real money and was redeemable for U.S. currency once the banks opened.

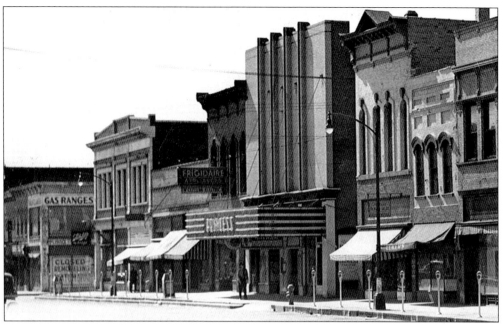

The 1930s rang in the era of modern architecture. In 1936, the facade of the Princess Theater in the old Busey Bank building was remodeled in the contemporary art deco style. Roger Ebert, Pulitzer prize-winning writer for the *Chicago Sun-Times* relates that his love for cinema was born while attending movies as a youth at this theater. The facade survives, and the building houses the Cinema Gallery. The east half of the old Spence block on the southwest corner of Broadway and Main Street also acquired modern looks in mid-century (below). Sporting a white brick facade with red detailing, the building housed Bean's Electric and Hardware Store before its demolition following a fire in a nearby building in September 1970, which prompted the leveling of an entire city block.

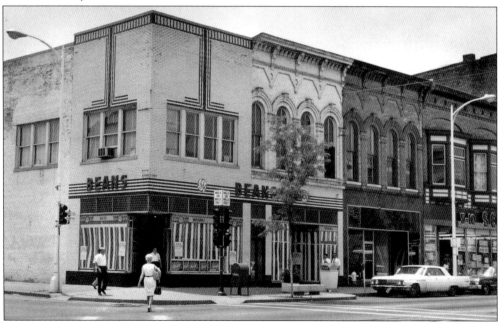

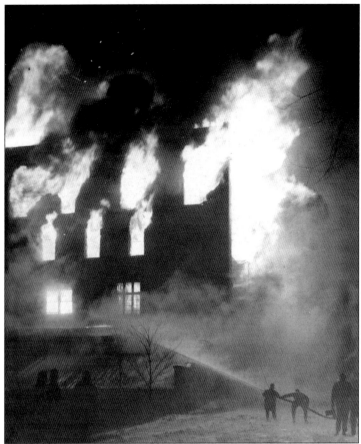

The burning of the Flatiron building on March 11, 1948, was the single greatest loss by fire that Urbana's downtown had experienced in the 20th century. The fire started in the early hours and spread quickly. The building was soon fully ablaze, and by morning, only the outer shell was left smoldering on the icy street. Architect Joseph W. Royer, who designed the building and whose office was on the third floor, lost all of his work.

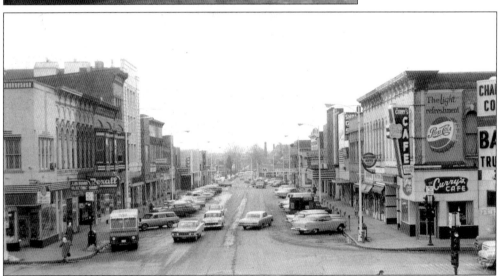

The loss of the building fundamentally changed the city's appearance, leaving a leveled, paved-over area, with a car repair shop in place of the primary symbol and anchor of Urbana's business district. This view was taken of Main Street after the loss of the Flatiron building but before the demolition of the Spence block (front, left side).

The 1940s were an unlucky decade not only for the Flatiron building but also for Urbana's other municipal symbol, the Champaign County Courthouse. Over that decade, its tower was hit by lightening several times, eventually necessitating the removal of its tall, Gothic steeple for safety reasons. The tower remained in this shortened state for over 50 years.

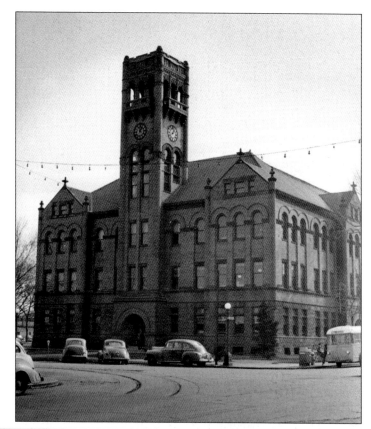

This photograph of Main Street from the 1970s shows the effects of the power of nature and modernization on the cityscape. In the distance is the courthouse with its stunted tower. The Spence block between it and the Tiernan building has been demolished. Several older business facades west of the Tiernan building were covered with modern billboard-style fronts, leaving the buildings devoid of windows and any type of ornamentation.

The USO Club on Elm Street west of the city hall (building on the right side) was used between the 1940s and 1960s as a popular hang out and dance hall for high school students, known as the Tiger's Den. In the 1970s, this entire block was torn down to make way for a city parking garage. The photograph below was taken of the east side of Race Street just around the corner. Looking south from Main Street to Elm Street, the picture shows the block before its turreted corner building was demolished in the 1970s. As had occurred in many other American cities in the 1960s and 1970s, the trend toward shopping malls and the demolition of so many downtown buildings had effectively reduced Urbana's prosperous downtown to a one-street-long shopping district.

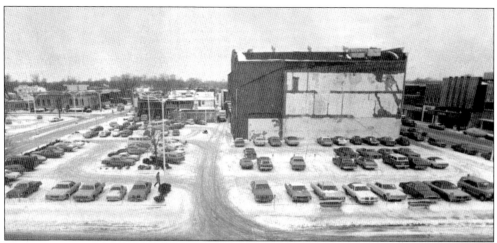

Following the fire in September 1970 that had damaged one of the stores in the west 100 block (formerly known as the Spence Block) on the south side of Main Street, the entire block was torn down. Demolition continued south on Broadway to Elm Street then west to Race Street. The scene above shows the leveled expanse of this once-busy downtown block after the businesses were removed. In the 1970s, a city parking garage was built over this parking lot. The city's most ambitious venture in modernization, Lincoln Square Mall, required the demolition of over 80 individual residences in the heart of downtown Urbana. The scene below shows the excavation for the new mall. When it opened in 1964, it was the first fully enclosed downstate shopping center in Illinois.

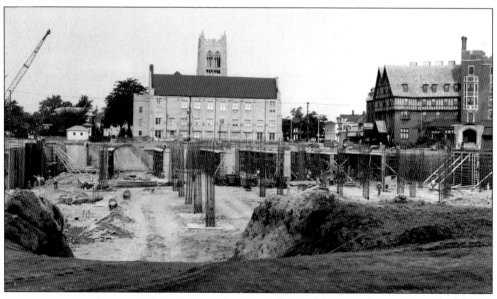

By the 1960s, the city administration had outgrown its old quarters, and a more spatious and modern building was erected for it at 400 South Vine Street. The new city hall, with fire and police departments, was dedicated in March 1966. Between 1995 and 1998, the building was expanded, and a second story was added (above). The Urbana Free Library (below) has also undergone two expansions since its construction in 1917 and 1918. The first one occurred in 1974 and 1975, when its size was doubled with a modern addition to its west side (back). The second addition was completed between 2003 and 2005 in the original Renaissance Revival style, at which time the 1975 modern addition was also refaced in matching style, reflecting a new aesthetic sensitivity. The new building features a coffee shop, Cherry Alley patio, and a large limestone sculpture carved on location. (DR.)

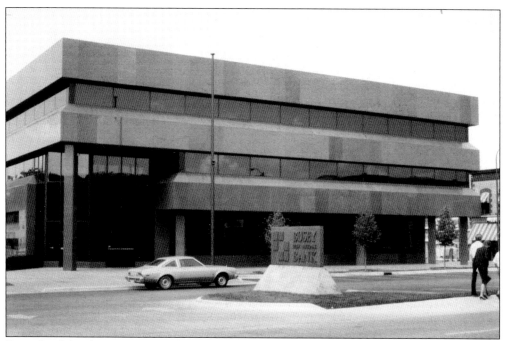

Busey Bank has been an essential part of the history of Urbana since its foundation by brothers Simeon H. and Samuel T. Busey, sons of Urbana pioneer Matthew W. Busey. The bank prospered, and in 1904, it moved into the building at the southwest corner of Main and Race Streets. The newest Busey Bank building, pictured here, was built between 1980 and 1982 west of the older structure, at which time the older structure was demolished.

One of the most notable recent additions to the university was realized from private donations. The Beckman Institute for Advanced Science and Technology was created in 1985 through a $40 million gift by alumnus Dr. Arnold O. Beckman, an inventor and philanthropist, to nurture scientific research and technological innovation.

Urbana is the boyhood home of Roger Ebert, Pulitzer prize-winning movie critic at the *Chicago Sun-Times*. A native of Urbana, Roger grew up in this home at 410 East Washington Street. He worked on the high school newspaper, graduated from the University of Illinois, and developed his love for movies at the Princess Theatre in downtown Urbana. Roger's portrait is from the 1960 yearbook of the Urbana High School. (DR.)

In 2008, Urbana celebrated its 175th birthday. Besides the public consumption of a 175-centimeter-long birthday cake and a parade featuring a five-foot-tall birthday cake float, the year-long celebrations included an archaeological excavation and the dedication of Founder's Park at the site of Urbana's first residence, the Isaac Busey cabin, a commemorative calendar, and scores of art programs. Here East Urbana resident Scotty Dossett marches and sings "Happy Birthday, Urbana." (NG.)

After attempts at modernizing the city's downtown in the 1960s and 1970s, a renewed appreciation for the city's history is being manifested in the restoration of the historic clock tower of the Champaign County Courthouse. After 60 years of neglect, the Citizens' Committee for the Clock and Bell Tower Restoration was able to raise $950,000 in private funds to begin the restoration in 2008. Today the nearly reconstructed tower stands as a symbol of Urbana's pride in its past and hope for its future. (DR.)

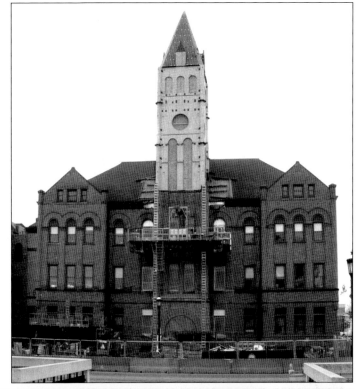

With a deep sense of appreciation, the authors wish to thank the staff of the Champaign County Historical Archives, located on the second floor of the Urbana Free Library, for their incredible assistance during the research for this book. Pictured from left to right are (first row) Norma Bean and Marnie Hess; (second row) director Anke Voss, Karla Gerdes, and Carolyn Adams; (third row) Eric Fair and Howard Grueneberg. (DR.)

ACROSS AMERICA, PEOPLE ARE DISCOVERING SOMETHING WONDERFUL. *THEIR HERITAGE.*

Arcadia Publishing is the leading local history publisher in the United States. With more than 3,000 titles in print and hundreds of new titles released every year, Arcadia has extensive specialized experience chronicling the history of communities and celebrating America's hidden stories, bringing to life the people, places, and events from the past. To discover the history of other communities across the nation, please visit:

www.arcadiapublishing.com

Customized search tools allow you to find regional history books about the town where you grew up, the cities where your friends and family live, the town where your parents met, or even that retirement spot you've been dreaming about.